To Toby - I thought you might
be interested in [...]ds

THE PRIVATE REVOLUTION:
WOMEN IN THE POLISH UNDERGROUND MOVEMENT

Belinda Brown

HERA TRUST

First published in 2003
by the *Hera Trust*

18 Victoria Park Square
London
E2 9PF
UK

fax. 020 8981 6719

In association with:

CEU/IFiS PAN
Centre for Social Studies
Warsaw

Copyright © Belinda Brown

The rights of the author
have been asserted in accordance with the
Copyright, Designs and Patent Act of 1988

All rights reserved

ISBN 0 9523529 2 3

Printed in UK by
Antony Rowe Ltd, Eastbourne

Cover design: Nick Green

In memory of my mother

Sussi Wendt Brown.

It was her love of Poland and its people
which first took me there.

Acknowledgements

I would like to thank the Central European University for giving me a place in which to carry out the research in Poland on which this book is based, and the George Soros Foundation for funding it. Particular thanks are due to my tutor Arista Cirtautas whose idea it was to talk to women about their role in Solidarity. I am also grateful to the late Professor Edmund Mokrzycki and to Professor Andrzej Rychard for their support both while I was at the Graduate School for Social Research (IFiS) and while I was at the Central European University. Above all I am indebted to the many women who agreed to be interviewed and who shared their time and personal experiences with me. I hope they won't object to the result.

While in Poland I was kept buoyed up by my friend Aldona Dyk with whom I shared many very happy times. Chris Vale was also a very ready listener whose patience, comments and suggestions helped me to explore my ideas. I am also deeply indebted to Maria Malewska who not only provided excellent care for Tomek but was a friend to me as well.

The Institute of Community Studies has provided me with an ideal environment in which to write and research. I am very grateful to the recently-deceased Michael Young for inviting me here, and to Peter Hall whose faith in me and my interviewing skills enabled me to get back into research. Also very important are the friends and colleagues associated with the Institute, whose presence goes towards making the atmosphere here such an amiable one. Geoff Dench in particular took an interest in my thesis and encouraged me to publish it.

Last but most importantly my thanks go to those who make up my own private sphere. My sister Cicely has always played an important role in helping me to stay focussed on my work. There are my parents-in-law in Przemyśl who have given me a second home. My father, who by reading everything I write and discussing it with me, encourages me in my work. I am also very grateful to my husband Marek. Not only is he always ready to answer my questions on Polish history, politics and culture but he has provided me with a warm and supportive environment which has enabled me to work. Finally there is my son Tomek, whose cheerful presence and interest in the world continually renews my own.

The Hera Trust is grateful to the *Mutual Aid Centre* for its generous support of the Trust's publication programme.

Contents

Gdzie diabeł nie może, tam kobietę pośle

(Where the devil can't go, women can)

Preface:
UNTANGLING THE PUBLIC AND PRIVATE REALMS

This book started out as an MA thesis at the Central European University in Warsaw, where it formed part of a group of studies using sociological concepts and methods to increase understanding of recent Polish history. My own particular concern then was to explore how the processes of daily life, at a private level, provided a foundation from which people could act upon and influence the shape of the public, political sphere. What I wrote then was obviously targeted at people who already knew a good deal about local events. It has therefore needed some editing to adapt it for readers outside of Poland. But nothing has been removed from the main body of the analysis, and no changes have been made to my original interpretation and presentation of the research material.

It is necessary to mention this, because since submitting the thesis I have slightly altered my views about the wider significance of the events and behaviour it documents. This may be in part because publication by the Hera Trust prompts some such re-evaluation. The Trust is committed to social investigation and commentary which assumes from the outset that women occupy a central place in society. This inverts many conventional western approaches to gender, and invites some reformulation of arguments. Any such influence by Hera will however only have confirmed a shift that has been taking place in my thinking anyway. If I step back and look at the personal context in which I conceived this study, then I can see that I chose this topic in the first place because of my dissatisfaction with the way that western feminism dealt with some fundamental questions about the nature of society, and also perhaps that carrying out this analysis has helped me in

resolving some of the ambivalence I felt towards their answers to these questions.

Feminism and the private sphere

I wrote this thesis after nearly five years of living in Poland, during which time I had developed some understanding of Polish culture and relations between the sexes. But its origins lie outside of Poland, in my time as an anthropology student, when I was learning all about feminist theory and how this fitted in with the concepts of the public and private sphere. According to this way of looking at the world women were universally subordinated. Actually the idea that women were universally subordinated was not just feminist, but it acquired through them the status of a given. Feminists enlightened us – with great inventiveness and ingenuity - about all the different ways in which this subordination occurred. And when you consider the immense variety of ways of living around the world that the idea encompassed, this was no mean feat.

I was never convinced by it, though. I had lived in many different countries, and seen women in many different situations. The idea that they were all subordinated to men simply didn't ring true. I was not subordinated for one - though I knew what feminists would have to say about that. They would say that I had succumbed to patriarchal ideology, that I could not perceive the true dynamics of my own situation. However the idea that there were people out there who could, and who had a better understanding of my own situation than I did, and could deny the validity of my own reality, was for me truly undermining. At the same time I felt obliged to accept their teaching. I was very grateful for the opportunities that I had - that I could choose what I wanted to do and wouldn't be restricted to looking after home, husband and children. I felt I owed a huge amount to women who had come before me, and this debt increased once I had child care responsibilities. So I never wanted to be disloyal to a cause from which I benefited, or undermine feminists in anyway. In short I had a seriously

ambivalent view about feminism, which I've been trying to unpick ever since.

Feminism did though have one glaringly obvious blind spot, on which everything else seemed to hinge. This was the notion that women were subordinated because they were associated with the private and men with the public sphere. So, for example, Sherry Ortner attributed the alleged subordination of women to:-

> Social-structural arrangements that exclude women from participation in or contact with some realm in which the highest powers of the society are felt to reside. (1974: p.69)

Henrietta Moore likewise explained that:-

> The feminist problematic remains the question of the origins of women's subordination and of male dominance in the political sphere of social life. (1998: p.132)

Like the feminists I had no problem with the idea of this universal association. But what nobody ever discussed was that this was only a *problem* if the private was believed to be less important, and the public considered the dominant sphere.

Def of private

Before going any further I should clarify what I mean by public and private since these words tend to be used in many different ways. By private I mean everything which pertains to reproduction and the arena in which children are brought up. This includes the domain of intimate relationships, and families, the social networks which extend outwards from these relationships and the social networks which develop around the care of children. The location of this private level is the home and other places which are brought into the orbit of the home through the extension of these intimate relationships outwards. So the location of the private sphere might also include local pubs, tenants' halls, churches, school gates and shared

residential space and so on. The public sphere I see as constituted by market mechanisms (including, very confusingly, 'private' companies), the state, and the media – in all of which people's behaviour is governed by impersonal rules and interests.

For most people, I think the ideal situation is one in which the public sphere is an area of collective activities which *serve* the private sphere. In many of the societies we study in anthropology it is also quite evident that this provides a mechanism whereby men are enabled or steered into serving women. The private realm is pivotal, and is responsible for the production and frequently distribution of food, maintenance of culture and tradition, distribution of information and of course the upbringing of children. The public sphere or the world of men was there to tend to the needs of the private. It sorted out disputes which occurred between families, helped to organise the production and distribution of goods, and helped to maintain the spiritual and religious side of life necessary for the perpetuation of agreed laws and values. If in the process the public sphere provided men with a certain amount of status, this status should not be confused with the real power women had to influence people, culture and values. Rather this status could be understood as a form of distraction or even compensation for what was really going on. Of course there is a huge amount of variation from one society to another. But the idea that the private sphere is the pivotal one is a model which can be applied and tested, particularly if sufficient attention is given to the women's point of view.

However, in large-scale and very complex societies many people do seem to feel controlled rather than supported or served by the public realm. And this I think may be a sentiment which has actually steered many women into becoming feminists. The idea that the public sphere rules is not hard to accept when living in London for example. People work ridiculous hours, reflecting their priorities. They seldom cook and certainly don't eat together - producing a very fragmented family and home. There

has been a surge in one person households, indicating that many are postponing or avoiding or escaping from family life. Through the market the public sphere takes increasing responsibility for a whole range of domestic services which are necessary to the running of a home. So we can hire people to do our cleaning and childcare, and go to other agencies to perform the full range of more mundane domestic duties. We can find people to walk our dogs. Even sex is increasingly provided by the shadow economy; this reduces the amount of time men need to devote to intimate relations, enabling them to give more time and energy to the demands of the public sphere.[1] In this kind of environment it is quite possible to believe that the 'public' is pulling all the strings.

This is the context in which feminist doctrines have emerged. In the west, ideas about society have revolved for the last two hundred years around the developing public realm; so this is where the power appears to lie. Marxism looked at the evolution of industrial relations of production and the home only became part of the equation to the extent it supported these. For liberals the individual was the measure of all things and he only really came into existence in the public sphere. The private was seen through the lens of the public; consequently, the role of women was ignored. However where these theories came unstuck was not in marginalising women, as feminists suggested, but in being blind to the centrality of the family and the home.

As the public realm appeared to increase in importance women, whose centre of gravity lies in the private, would have felt increasingly sidelined. In this situation they had two alternative courses open to them. Either they could look for ways of increasing the standing and powers of the private sphere, thereby restoring more control to themselves. Or they could jump while the ship was sinking, and campaign for an equal position in the public realm. Feminists chose the latter route. In

[1] Cohen N., 'Boom Time for London's Sex Trade', *Evening Standard*, 22/11/01.

so doing they colluded with those philosophical trends which were obscuring the value and importance of the private realm. So for example Sherry Ortner, under the mantle of feminism, was lauded for writing in these terms:

> In other words, woman's body seems to doom her to mere reproduction of life; the male, in contrast, lacking natural creative functions, must (or has the opportunity to) assert his creativity externally, 'artificially,' through the medium of technology and symbols. In so doing, he creates relatively lasting, eternal, transcendent objects, while the woman creates only perishables – human beings. (1974: p.75)

In fact in the early years of radicalism the processes of reproduction became so strongly associated with oppression that some like Shulamith Firestone argued that liberation would not be achieved until technology became advanced enough to free women from childbearing altogether. This style of thinking became dominant because the dictats of feminism asserted that there was no other valid way of thinking outside of the feminist point of view. Other frameworks we use, women were told, were a product of a male style of thinking, and could therefore only end up supporting a male point of view. As Sheila Rowbotham explains, conventional approaches to relations are "constructed from the experience of the dominators and consequently reflect the world from their point of view, however they present it as the summation of the world as it is" (1969: p.5). Not only are our concepts male but apparently we lack vocabulary as well:

> We have accepted for so long man's image of himself and of ourselves and the world as his creation we find it almost impossible to conceive of a different past or a different future. MANkind is his, woMANkind is his, huMANity is his. We have not even words for ourselves. Thinking is difficult when the words are not your own. (ibid: p.4)

And even if we could speak, according to Rowbotham we don't really *know* ourselves. "Communication for people who have no name, who have not been recognised, who have not known themselves, is a difficult business." It meant that "the revolutionary [feminist] who is serious must listen very carefully to the people who are not heard and who do not speak" (ibid: p.4). With this as a starting point there was plenty of scope for creativity and the feminists did not really listen to everything *we* had to say.

As a result little attention was given to the range of meanings which might be attached to home and work, the alternative forms of power found within the home, and outside it, the meanings given to housework and childcare, and the significance of friendship networks or the different ways of perceiving male and female interaction which do not depend on relations of domination and subordination. In short when Sheila Rowbotham and others argued that our concepts were a product of a male style of thinking they might well have been right. However in attaching so much importance to all things 'public', it was the feminists who had adopted a male point of view.

Abandoning ship

The lack of attention paid to the private sphere has now to some extent been rectified; the pendulum is swinging steadily the other way. There are studies that acknowledge the importance of female decision making in family situations and which reassert the centrality of the family and home. A look at almost any issue of *The Guardian* will testify that childcare and relationships are now popular subjects even amongst feminists themselves. However this renewed emphasis on families and private issues has not been accommodated by new feminist theorizing. Nor do feminist perspectives provide much motivation for political activity any more. Feminism seldom acts

as a catalyst for debate and discussion; it appears to have atrophied. Some might think it was almost dead.

However to overlook feminism in this way is a mistake. Its legacy is very much with us and still calls the tune. It has opened up areas of employment and creative venture to women in a way which was not available before. It has helped to create far more liberal attitudes towards personal relationships. But there is a more subtle and indirect legacy of feminism and it is this which I would like to look at here.

In order to free women up from the family duties which so oppressed them, feminists were keen to hand such responsibilities over to the state. This has resulted in a situation where, in Britain in particular, the state increasingly intervenes in issues on how we manage personal relationships and family life. So for example in a recent series of interviews conducted in schools in London, teachers expressed resentment over the fact that they had less time and resources to devote to a child's education since schools were expected to take increasing responsibility for a child's welfare. They had to be involved in building partnerships with social services, the police and sometimes even parents as well, in order to provide counselling and other facilities aimed at giving the child much needed emotional support. (Buck *et al.*, 2002: p.181) The increasing role of schools in non-educational issues is also reflected in the provision of breakfasts and an ever lengthening school day.

In the same vein the Home Office under New Labour has been introducing a range of initiatives whose intention is to provide advice and guidance in the management of relationships. Following on from the Home Office document 'Supporting Families', the *National Family and Parenting Institute* and *Parentline* were set up, not to provide practical assistance but rather to "encourage recognition that parenting is an important and complex task, seeking to change the culture so that asking for help and support at an early preventative stage is seen as a sign of responsible parenting" (Home Office, 1997: p.9). Manage-

ment of private relationships is being turned into publicly transferable skills, and the state aims not only to advise parents on how to be parents but also to teach children this skill in turn. "How to be a parent is one of the most important skills a child can learn, and we cannot rely on children picking this skill up from their parents, or from other sources such as friends or television" (ibid). In the latest development the Lord Chancellor's Department, which exists to oversee the administration of public justice, has started issuing guidelines to couples on how to negotiate their relationships.

So when it comes to our family and intimate relationships the state, as Ellie Lee explains, is increasingly trying to get in on the act:

> The message seems clear; if we leave the job of socialisation to people, outside of the influence of the expert, the result will be disastrous. We must, instead 'create a culture' where people automatically look to educators, advisors and experts because the complexity and difficulty of living and loving makes this project too difficult for us to cope alone. (2002: p.3)

Of course, rather than supporting our intimate relationships third party intervention could actually end up undermining them. As Ellie Lee goes on to explain:

> This project can also be considered counter productive, however, because an agenda supportive of third party 'support' encourages us to short-circuit the process of working out how to relate to others for ourselves. I consider this to be an important process, and in our lives as partners, spouses, parents or friends, we will do better if we by and large try to see through our own attempts to resolve problems and work our solutions, without outside intervention. We may do better if we trust in ourselves and those who know us best, and we may well find that in fact we do not need to be 'empowered', 'educated' and 'supported' in order to be

able to be intimate, and that we can cope alone. (ibid: p.4)

Part of the reason why policies often seem so blind to the realities of family living is because increasing the numbers of women in public life has actually weakened rather than strengthened the connection between politics and the private sphere.

Women who make it to decision making positions will often be those who have either not had children, or, if they did, delegated responsibility for looking after them to other individuals who may be neither equals nor necessarily very close. Consequently these powerful women have little in common with the rest of us mortals unless one attaches a great deal of importance to sharing the same sex. At least men in powerful positions usually had a reliable interviewee, a wife, who could persuasively share with them the realities of life in the private sphere.

Finally because the focus of feminism was very much about creating equalities between men and women in the public realm it has tended to ignore wider issues of inequality. So while men and women may have achieved greater equality there is greater inequality between public and private as a whole. This is reflected in the fact that jobs related to the provision of a whole range of domestic services; cleaning, food preparation, care of the very young and elderly, home renovation are the poorest paid areas of employment. These jobs may no longer be exclusively performed by women. They have moved also into the hands of another type of second class citizen, the immigrant whose rights are in other ways considerably reduced. Feminism has resulted in a situation where we focus on the superficial manifestations of inequality such as that between men and women while leaving the deeper structural sources of inequality to carry on being reproduced.

Some of the above has become clearer to me in recent years. But much of it I was already feeling when I set out for Poland in

1991. And this is perhaps why I looked at things in the way I did.

My Polish lesson

Poland could hardly have presented a greater contrast. In Britain as in western democratic societies generally the state provides a central source of personal security and identity which offers a real alternative to dependence on a family and private household. The growth of factory production and resulting mobility of labour, development of Empire and liberal constitution, and of the postwar welfare state, have all contributed to a strong sense of citizenship in which dependency is acceptable in the public as well as private spheres.

But in Poland history has taken a different course. Not only has the formation of a state system been more tentative and faltering than in the west, but insofar as it has taken place at all it has so often been authoritarian, and imposed, and alien that the public arena has never enjoyed the easy legitimacy which we take for granted in Britain. Consequently the social centre of gravity has never moved into the public sphere; to the contrary the private remained crucially important. Where the private sphere was socially cohesive and integrated I found through my research that it was able to exert an influence on the whole.

For 123 years, under the partitions (see pp.27-8 below), the Poles had to make do without a Polish state. In terms of day to day living this meant that they no longer had access to certain jobs which might have given public power or status. And where they *did* they often did not take them, since public esteem would have meant compromising their private integrity. There was also a lack of legitimate political power. At the same time social and economic measures imposed by the occupying powers meant that nobility were frequently deprived of their land and property, and their titles were also abolished, leaving many lesser nobility no better off than serfs. In some areas people were not allowed to speak Polish in public places; nor was Polish

language and culture taught in schools. This was all part of the
process of denationalisation which accompanied attempts to
assimilate Poles to the cultures of the occupying powers instead.
So instead of following a trajectory of citizenship upheld by a
state, people invested in the more hopeful concept of a Polish
Nation. This nation was maintained not by public institutions,
but by the family, through which people learnt their values,
language, culture and tradition. Through the family people learnt
that they were Poles:

> In this situation, the family took on an increased
> significance, because it represented a sphere that was
> still more exclusive and screened off than Polish
> organizations and even than the Polish Catholic Church.
> It was out of the hands of the Prussian control
> apparatus and thus represented a last impregnable
> bastion of 'Polishness'. In family circles, the Polish
> language, the use of which was forbidden, even
> persecuted, in the outside world, was used exclusively.
> Here, Polish prayers were peacefully prayed, Polish
> songs were sung, Polish customs were cultivated, and
> Polish history and tales were related. In this way, the
> members of the next generation received a
> thoroughgoing and consistent initiation into the Polish
> national culture from the earliest childhood and were
> brought up with a corresponding self-confidence.
> Again, Polish mothers and grandmothers were mainly
> responsible for fulfilling this important task, surely more
> as a matter of course in rural families than in urban
> ones. (Jaworski, 1992: p.55)

Also important in maintaining the idea of a Polish nation was
the Catholic Church. In this it had an ambivalent role. On one
hand it did not provide any support for the various Polish
uprisings, and this gave deep offence to the Poles. However it
provided individuals with a value system, and structure to their
lives, and institutional support for their families. It also gave an
important sense of continuity, as Norman Davies points out:-

> What is more, the history of the Roman Catholic Church provides one of the very few threads of continuity in Poland's past. Kingdoms have come and gone; but the Church seems to go on forever. (Davies, 1983: p.208)

Furthermore the traditions, beliefs and values which go towards making up the culture are all in their origins Catholic, and it is these which provide such a vital social glue and give the Poles a sense of themselves. This was all the more the case under the partitions where their Catholicism helped to set them apart from the Orthodox Russians and the Protestant Prussians. So although Poland has in the past been an exceptionally multicultural and multifaith nation, under the pressures of maintaining national identity Polishness over the years has become synonymous with Catholicism.

Thus to crudely sketch the resulting situation, there was a highly valorized private realm which revolved around home and family and which was supported by the Church, and an imposed and alien public arena. Public status and power did not translate into private importance and esteem, and private importance was not reflected in the public sphere. This did not mean that the private could not act on the public. Indeed I suspect that it was due to the strongly interlocking nature of personal social networks that the Poles could provide the systems of education, and carry on nurturing Polish culture, as I briefly describe in chapter one. If there had not been a dependable system of support, a safety net, I doubt whether the persistent uprisings could have taken place.

The private realm was also able to emerge in the public, challenging its hegemony in a symbolic and effective way. Bogna Lorence-Kot recounts for example how following the death of a number of Poles in anti-Soviet demonstrations, women forwent their usual colourful clothes, choosing to wear only black. However on a national holiday they resumed their usual colours, irritating the Soviet authorities so much that many were

arrested. After this the Soviet authorities actually made it illegal
to wear black and subsequently, in order to keep up with the
continually moving goalposts, it also became illegal to wear grey
and brown. Women who wore these colours without personally
being in mourning could be fined large sums of money, and on
occasion government agents tore at their dresses with large
hooks. (Lorence-Kot, 1992a) It is a tribute to the power of
essentially private activities that the occupying powers felt
threatened in this way.

Where the private realm is central in people's lives women are
important in a way which either no longer exists in the west or
to which we are blind. In the Polish case awareness of the
centrality of women was heightened by their role in supporting
nationalist activities. For example Lorence-Kot recounts how
women acted in an ancillary capacity, supporting military actions
and also serving as couriers, nurses and liaison. They helped the
families of captured men and brought aid to those in prison.
They disseminated forbidden literature, taught children in secret
schools and took part in public political demonstrations.
Rudolph Jaworski describes how the contribution which women
made varied across classes:-

> Women from the upper classes were chiefly concerned
> with all questions connected with the preservation and
> care of Polish culture and education. The women of the
> business and trade middle class were certainly the
> protagonists of the attempts at national-economic
> independence and delimitation, while the represen-
> tatives of the agrarian and proletarian milieu were
> prominent on the elementary discussion of speech and
> religion, as demonstrated by the Polish schools strikes.
> (1992: p.63)

Nor did the importance of women go unrecognised as feminists
so often suggest. So for example Count Berg, a high ranking
Tsarist functionary, singled out the women because of their zeal,
courage and self sacrifice, and said that their actions were

unmatched in other countries and of great consequence for the Polish nation. He placed women in the midst of conspiratorial activity and defined them as more constant than the men. (Lorence-Kot, 1992: pp.36-37) Likewise no less a figure than Bismarck said that, "As long as there is still a Polish woman, there will also be a Polish question". (Jaworski, 1992: p.63)

Without wanting to be too deterministic about this, it does seem that the patterns established under the partitions are likely to have provided some kind of template for Poland under the later communist regime. For whereas the period of the partitions lasted a total of 123 years, the period of statehood *between* them and Soviet occupation lasted only 17. This is not enough time for new patterns of social organisation to take a significant hold. The similarity of conditions under the partitions with those during the communist era suggest considerable continuity of national experience, so that socio-cultural patterns established in the earlier period would have provided an appropriate cultural resource for tapping later.

Strong efforts were made after World War Two to rebuild a Polish state. But there were many obstacles. Much of the country had been ravaged by the war. Private property had been appropriated. Enormous population shifts had taken place, in addition to the massive casualties. All the pre-existing authority structures whether in terms of property (landowners, industrialists and the state), education (the intelligentsia), or the urban elite had been completely destroyed. Under these circumstances the period between the world wars did not prove long enough to change the realities by creating a confident Polish state, or go far in reducing dependence of society on the private realm.

The war was followed by the imposition of an authoritarian system, the centralised communist state. However the extent to which it could control people's lives had some limitations. There were fault lines running through it which in the long run rendered it quite weak. Not least of these was the inefficiency of

the economy. This along with the systematic preference for heavy industry meant that there was a continual shortage of consumer goods. People therefore relied far more heavily on informal mechanisms to obtain what they wanted, which increased their independence from the state. The continued existence of private agriculture (85% lay in private hands) ensured an ongoing supply of agricultural produce. This coupled with significant amounts of illegal currency coming from those working abroad ensured that an energetic informal economy was sustained.

Once goods entered the informal economy, they tended not to be bought and sold but rather bartered and exchanged for a range of material and non-material goods. This meant that they were operating according to processes which, unlike money, did not require state legitimisation. Furthermore, within these market networks, exchanges for money tended to be socially stigmatized. Independence from the state legitimating processes was accentuated by the fact that the final exchange value of the good is not determined by the market but rather by symbolic and subjective exchange values inhering in it (Pawlik, 1992).

Finally the habit of investing time and energy searching for informal access to goods became institutionalised and people preferred to obtain goods that way even when they could obtain them easily and cheaply through state stores. A very dense network of social relations built up around these informal networks, typically consisting of 20-30 or more individuals who maintained a high degree of contact. In addition to the purely practical function of obtaining goods a hidden function of the interaction was the further integration of people into their *środowisko* (social environment). Pawlik (1992: p.90) explains that "exchange contributes to a significant warming of relations within the circle as daily collaboration in resolving everyday problems widens the realm of co-operation to areas of life beyond the economic". Such processes weakened the hegemony of the state and contributed to the strength of the private sphere.

The work ethnic under the communist system was very poor, as Norman Davies points out:-

> The Poles, above all, are patriots. It has been proved time and again that they will readily die for their country; but few will work for it. As the authorities periodically confess 'labour problems' continually disrupt the smooth flow of economic progress. The workers feel little sense of identity with the state enterprises for which they labour, and in whose management they have no real voice". (1983: p.623)

However there was little which a socialist state could do about this since they could not use the labour market, firings, lockouts, threat of unemployment or bankruptcies as could be done in the West. The means for disciplining labour under socialism were far less subtle and varied than those under capitalism.

Other ways in which the state was weak are discussed in more detail in chapter four. They include the scepticism with which all communist media was regarded (perhaps best expressed during the period of martial law when many inhabitants would put their televisions facing outwards on the window sill when it was time for the news), the inadequacy of social service provision, the lack of faith in political processes and so on.

Where the state was weak in this way, the responsibilities of the private sphere increased and women came to have an increasingly central, even if burdensome role. This, as I try to show in this thesis, became particularly apparent during periods of resistance, as for example during the formation of Solidarity and later through martial law. Others have commented on the strength of Polish women and also trace this back to historical circumstances:-

> The feminists to whom I am speaking hardly seem to understand the concept of female weakness. They look uncomprehending when I talk about fifties' stereotypes

of passive, ornamental femininity, of the half childish,
doll-like women. "I've met a woman once who tried to
style herself as a sort of doll," somebody says, combing
the recesses of her mind to come up with this, "But she
was hardly passive". Indeed, in public life and in private,
I keep encountering women whose spark and strength
and personal authority seem quite formidable.
Altogether, in the elusive realm of cultural values, there
seems to be less of a division between 'male' and
'female' virtues here, and female valour, intelligence, and
strength of personality are as highly prized as the male
versions. (Hoffman, 1993: p.72)

The centrality of Polish women is continuing to this day. A
recent article reports that 30 % of managers in large companies
are women and 38% of owners of small and medium sized
enterprises are women - a far higher percentage than anywhere
else in Europe. After 1989 the number of firms started up by
women increased threefold, as against twofold for men. Even in
more 'male' branches of enterprise such as transport and
building 27- 30% of the directors are women.[2]

However this has not been achieved through reduction of
domestic duties, or by seeing their interests as fundamentally
opposed to men's. Rather I would suggest that the role which
women have in public life has evolved out of their role in the
private sphere. For example, the article discussing this 'Business
matriarchate' attributes women's dynamism to the role which
they had under communism in 'filling fridges, buying washing
machines and televisions' and so on. Going further back the
author points to the role which women had in holding the
family together when men were fighting or sent to Siberia. The
fact that 80% of women managers in Poland have children
compared with only 58% in Britain would seem to back this up.
Nor did Polish women see themselves as competing with men.

[2] Geremek Rafał, 'Matriarchat Biznesu: Polki sa najbardziej przedsię
biorczymi kobietami Europy', in *Wprost* 26 Stycznia, 2003: pp.54-57.

Whether it was under the partitions, or under martial law, they together fought a common enemy from the same side. "You know, we've had all these problems we had to deal with together"... "We've always had to struggle, and in some respects we tried to help each other".

The resulting situation would have been an anathema to traditional feminists. Women stuck by a conservative Catholic Church. They conformed to assumptions about their social roles and fulfilled traditional expectations concerning family and home. Yet at the same time they were very visible and effective in the public sphere. Although under communism there may have been more employment and educational opportunities than in the West, they also had many more responsibilities. So this is only a small part of the explanation. To understand why Polish women have always made the most of the opportunities available one needs to understand their role in, and the importance of, the private sphere.

At the time of writing up my research I felt that most of this could be put down to the extremely hostile environment in the public realm – making it hard for men to assert domination. Private life was more important than in the west because of the relative weakness of the legitimate public realm. This is the lesson I drew. But since coming back to London, and seeing how things are moving here, I have disinterred my doubts, revived my hesitation, and considered the issues yet again.

Bringing it all home

In my thesis I concluded that it was the strength of the private sphere in Poland which enabled people to act decisively and effectively to overthrow the communist regime. In the absence of a legitimate public sphere, the private was able to mobilise greater power even than that of the authoritarian state system itself. What I did not really appreciate though, until living back in London again, was the extent to which the same might be true in apparently male-dominated western states too. Behind

the veil of patriarchal domination, women and families might be much more powerful than they appeared. Anxiety about sinking ships might be entirely misplaced.

While not realising it immediately, I was however more alert to it than I would have been otherwise. I soon picked up that things in Britain were changing, and not along the lines predicted. The feminist manifesto declared that as more women entered work, government and the civil service, and became powerful in business, that women's concerns would become more influential and life would improve. But that was not what was happening. Women were indeed making steady progress in occupying the public realm. Life, though, was not improving. On the contrary, the gap between rich and poor was growing. The alienation between the political class and the masses was deepening, and beginning to undermine the legitimacy of even the gentle British state. And relations between men and women were, if anything, even more poisonous. Family life seemed on the edge of collapse, so that ever more women were running away from it to the security of dependence on public realm supports.

Looking back now I can see that this was when I seriously started to question the equation of state power with male domination, and to see that the strength and health of the private realm might not depend on male attitudes to it so much as on women's. Even an apparently stable public realm such as in Britain might not be able to stay legitimate unless informed and underpinned by the private realm.

There could be no doubt that the British state in the 1990s was listening – attentively, even anxiously – to what women had to say. But perhaps it was listening to the wrong women. For now that there were women prominent in the public realm, they had gained a voice in the public arena, with routine access to political leadership. However, these were almost by definition women who were most like men in their attitudes, and least in tune with those women still holding the private realm together.

In the old days, women whose lives revolved around family and community had the ear of husbands and sons active in the public sphere. They could expect, and did expect, some notice to be taken of their views. But now there were professional 'women' out there with a self-proclaimed mandate to speak for women direct; so these husbands and sons had become silenced. And this, perhaps, was what was dislocating the link between realms. The feminist strategy of infiltration did not create a conduit through which women's needs and values could shape policy. Rather, it was cutting off the influence of ordinary women.

The situation was getting bad – but at the same time it was now so evidently bad that a reaction was setting in. Books were starting to appear which dared to connect the decline in community spirit to neglect of the private realm. Some of these, like *Transforming Men* by Geoff Dench (available in Polish as *Pocałunek królewny*) were explicitly linking this to the feminist revolution and its misunderstanding of the nature of patriarchy. This was not, he argued, a licence for male domination. In reality it was more of a device for domesticating and managing men by making them formally responsible for families. Behind the veil of male leadership, the family man was taught to give priority to private realm concerns, and become responsive to women's needs and desires. Attacks on patriarchy were liberating men from this discipline.

By the time of my writing this preface, there are strong signs of a counter-revolution on the way. Motherhood is very firmly back in fashion, with many women who had thought that they did not want children now worrying collectively that they may have left it too late. There is a steady and noisy stream of female top executives and media stars declaring very publicly their desire to put family life first and stepping back into the private realm. Magazines advertising bridal wear are reaching unprecedented levels of popularity amongst schoolgirls. And most indicative of a revival of the private realm, interest is rising generally in churches – with an interesting transformation of

some of my friends who used to be staunch socialist campaigners into ardent defenders of an older faith.

As yet there is no sign of any real change of heart within the political class. New Labour is still populated by a cohort of state-oriented feminists who assume that women's power and happiness is dependent on processes of direct political representation and access to employment. This is being questioned by those disillusioned by these processes and those who feel that the expectations of the work place detract from their family life. The public realm has clearly lost touch with the private, and is losing too its legitimacy – fast. But there are now enough articulate dissidents to generate a political debate on gender issues. So we may see growing support in the near future for a revival of investment in the private realm.

What this will require, above all, is greater respect for the feelings and values of the women who keep the private realm operating. And this means some moderation of the current emphasis on the individual which, as Alison Jagger points out, is based on a thoroughly male set of reflexes and assumptions. The idea of a free, rational, autonomous being cannot accommodate the female sense of interdependency which comes out of caring for children. As Jagger explains:

> Women who spend their lives weaving webs of human relationship and defining themselves and others in terms of those relationships, are not likely to think that individuals are prior to the community in any meaningful sense of the term prior. (Tong, 1995: p.35)

Once we start taking this more 'female' perspective seriously, many of the assumptions by which feminism lives and breathes are undermined. For example the fact that there may be more men in highly paid jobs may not be a sign of female subordination. Instead it could be because women put more of a premium on jobs which give opportunities to interact with others as equals than those which give them status and high pay.

(Elliott & Chittenden, 2003) Perhaps women are less keen on dealing with competition since they may be more aware of the threat this involves to their relationships with others. Alternatively they may think it is more valuable to bring up children.

If we see things from the perspective of relationships and interdependencies as outlined by Jagger, men and women cease to be individuals engaged in ruthless competition with each other for public resources, a competition in which women may always come out last. If we take a private-centred point of view then issues of public status and power, the life blood of much feminist campaigning, cease to be of consequence in themselves, and we can start to heal the wounds created by the pursuit of inappropriate goals and worship of false gods. The strategy of western feminists has had a long innings, and is not delivering on its promises. It is time now to look around the world with fresh eyes, not in order to impose on other societies our own narrow view of them, but to see what can actually be *learnt* by us from the experience of women living under very different conditions. I hope that this study can play a part in that process.

Ch.1
RESISTANCE IN POLISH HISTORY

The aim of this study is to explore the importance of the private sphere, and thereby the role of women, at the public political level. In so doing I hope to highlight the limitations of most political theory, which concentrates entirely on the public level, and show how a more complete picture is provided by including the private sphere. This will be done by examining the role of women in the Underground movement in Poland during the 1980s, and looking at the importance of that movement in the transformation processes as a whole.

By concentrating on women, who are more strongly associated with the private level than men, I hope to develop a clearer picture of the relationship between the private domain and Underground society. By concentrating on the Underground, I hope to fill in gaps in our knowledge which arose from the impracticalities of researching it during its existence, and were not filled in the greener period of transition sociology which came after. The Underground and the crucial role of women within it are under-researched due to the latter's location in the private sphere. By drawing attention to this I hope to provide a more rounded model of the processes of transformation and show the importance of including analysis of the local level in policy formation and sociological discourse.

In this chapter I look at how the private sphere became so important in Polish society and the role it played in sustaining a continuous undercurrent of resistance against Soviet domination. By looking back at over two hundred years of Polish history I can suggest how recourse to the private sphere and resistance to alien domination were adaptive responses to the conditions in which Poles found themselves and together

offered the only way in which some kind of independent identity could be sustained. The second chapter will explore the hidden, but central role of women in the Underground and show how it was influenced and even facilitated by traditional social structures. It will consider the possibility that the nature of women's activity made it more suited to Underground conditions than men's. The limitations to this activity will also be examined.

The third chapter will locate the importance of this Underground activity in the transition as whole and indicate how it led to the gradual transformation of the public sphere, between 1981 and 1989, culminating in the round table discussions. It will also examine the process by which Solidarity became increasingly undemocratic, and show how those who were most active in the Underground were eventually excluded from political negotiations and therefore from being central participants in the processes of change. Women are not mentioned explicitly. But their presence is implicit in discussions on the tribulations of the Underground.

The final chapters deal explicitly with women, by examining other reasons for their exclusion from political processes. These are located in women's traditional importance in the private sphere, and the enhanced significance of this sphere in Polish history. It explores the way in which this private level has had, and continues to have a crucial role at the public political level, and sees the way ahead for women, and society as a whole, not just in the promotion of women in the political hierarchy, but by including the grass roots, local and private level in political discourse.

Defeat and defiance

Polish history is heroic, exciting and all too often tragic and to try to cover over two hundred years in a few pages invites doing it an injustice. It is perhaps a feat which one should not attempt. On the other hand what the Polish people have been through

has shaped their national identity and their culture and made these very important to them. So to ignore Polish history might be an even greater sin. Also the past helps to illuminate the present and by looking at where they were metaphorically coming from we have deeper insights into what was going on. So, for example, Norman Davies needs to refer to the fact that, "People's Poland is the heir to attitudes bred in the conditions of Tsarist Russia and multiplied by the strains of two successive German occupations," in order to explain how people felt about the state over one hundred years later (Davies, 1983: p.598).

Thus by looking at Polish history we see that difficulties in imposing communism on Polish society were not only about the stupidities of the communist system. Nor were they solely about the incompatibility between communism and Polish structures of production (which Stalin described as saddling a cow and the Poles thought was like yoking a stallion). If we look at the past we see the Poles had far deeper undercurrents of resistance, and resources to draw on, which meant from the outset it was very unlikely to work.

In the eighteenth century the Polish state was very weak. The *szlachta* (nobility) were keen on preserving an atavistic fragmented feudal state for their own benefit and this had inhibited the formation of a bourgeoisie and free labour force, delaying the development of capitalism. They were reluctant to pay the taxes necessary for maintaining a standing army, because they felt this could lead to a strong state which could work against their interests. Above all perhaps was their system of *liberum veto* which, whether motivated by their love of freedom and equality, or an unwillingness to compromise, led to corruption and inefficiency. Poland's neighbours Prussia, Russia and Austria took advantage of this weakened Polish state and agreed to divide it up amongst themselves. The first partition was in 1772, the next in 1793 and with the third in 1795 the state of Poland ceased to exist.

The Polish people did fight back, regardless of the greater strength of her neighbours, and were each time brutally repressed. The first significant resistance to undue Russian influence was the Confederation of Bar from 1768-1772. This was crushed by the Russians, and with 5000 *szlachta* sent to Siberia it was dealt a very heavy hand. The fall of the Confederacy led to the first partition of Poland.

Despite this the King launched a reform programme which led in 1791 to the Third of May Constitution. This was preceded only by the American Constitution and was widely hailed for its progressiveness in the Western World. However the partitioning powers felt threatened by this, and in 1792 Russia instigated, through a handful of Polish magnates loyal to her the Confederation of Targowica, which challenged the new constitution. On this basis Russian troops were sent in, and war broke out. Despite a heroic resistance the Poles were eventually defeated once the Prussians also joined in. This led to the Second partition.

Popular discontent led to another uprising lead by General Kościuszko in 1794. Although initially the people of Warsaw (led by cobbler Jan Kiliński) defeated the strongest Russian regiment in Poland, the combined forces of Prussia and Russia once again led to a Polish defeat. The Russians killed the inhabitants of a whole neighbourhood in Warsaw (including women and children) and again many were sent to Siberia.

Another insurrection took place in 1830 which resulted in a terrible persecution and another 25000 people being sent to Siberia with their families. In the January uprising of 1863 the Poles managed to last out against the Russians for a year and a half, but that too was brutally suppressed. One might imagine a non-existent nation to have become more submissive when persistently meted out such punishment. However it doesn't seem to have worked like that with the Poles. Instead they became practiced in how to resist.

This foreign domination was accompanied by repression which varied in intensity between time and place. For example Tzar Alexander I, the head the Congress Kingdom, was a liberal ruler and from 1815 till 1825 the large part of Poland under Russian rule had a relatively peaceful and prosperous time. This really changed after the 1830 uprising, which resulted in repression followed by massive political migration, and then again after 1863 when a far more intensive form of Russification was imposed. The University of Warsaw and all schools were closed down, use of the Polish language was forbidden in most public places and the Catholic Church was persecuted. Russia also adopted the policy of undermining the economic basis of the Polish nobility with the aim of breaking their political power. Many lost their privileges, leaving some no better off than serfs. Goods were confiscated, there were enforced contributions to the state and whole groups were eliminated from economic and social life as a result.

Likewise in the Prussian zone the aim was to destroy totally Polish language and culture, and from 1872 German became compulsory in all schools and it was a crime to be caught speaking Polish. Also there were systematic attempts to uproot peasants from their land. In Austria too attempts to maintain Polish culture were repressed, although after 1868 things changed. Kasprzyk comments here how, "The Poles had a degree of self government, the Polish language was kept as the official language and the Universities of Kraków and Lwów were allowed to function. As a result, this area witnessed a splendid revival of Polish Culture" (Kasprzyk 1997: p.12).

With the Polish state weak or non-existent the survival of Polish identity and culture came to depend upon the family. As Bianka Pietrów Ennker explains:

> Since Poles were now excluded from all responsibility for running their own land, the inculcation of national awareness came to devolve entirely upon the family. The latter became a stronghold of national identity

during the whole of the time when Polish public life was
hamstrung by the dictates of the partition powers (1992:
p.11)

In this way Polish society's centre of gravity moved into the
private sphere. The central place of the family was recognised by
the movement of national reform, which emphasized the nation
above all else, and opposed measures taken to promote the
interests of individuals or privileged groups since this was seen
as being divisive to the interests of the nation as a whole. Rather
they saw the family, with its key role in the socialisation of
children, as the instrument through which national pride would
be sustained.

This also made children very important since the future of the
nation lay in their hands. The didactic literature of the day was
directed at the best way to raise the ideal citizen, the traits he
should exhibit, and above all how a mother could bring this
about. Concern with the best way of achieving the right moral
and physical conditions for a child reached almost obsessive
proportions and concentrated on education, marriage and above
all on maternal attitudes and behaviour. Collaborating in all this
was of course the Church, which encouraged a self-sacrificing,
self-abnegating role for mothers. This is perfectly expressed in
Matka Polka, a symbolic icon which captures notions of
maternal self sacrifice and hard work; an ideal for Polish women
in the nineteenth century which continues to this day.
Education and the transmission of Polish language and culture
was also essential to maintaining national identity. This was
achieved through a network of illegal schools which too grew
out of the private sphere. Norman Davies explains:

> Thousands of young people of both sexes who recoiled
> from illegal acts, found a mission in life by fighting for
> Polish culture. In Russia, the typical Polish 'patriot' of
> the turn of the century was not the revolutionary with a
> revolver in his pocket, but the young lady of good
> family with a text book under her shawl. In Prussia and

Austria, where political organizing was permitted, Polish schoolteachers formed the backbone of the national movements. (Davies, 1983: p.233).

These people were not merely concerned with maintaining language and culture within the more privileged sections of society. They also extended the process so that peasants would be brought into the educated fold. This was done through a process of informal organisation where individuals were found who were willing to be educated and to help educate others. In this way education would spread through the communities. Their achievements were enormous:

> In thirty years of ceaseless activity, the cultural patriots not only neutralized the efforts of the Germanizers and the Russifiers; they actually began to overtake them. By the turn of the century, the state system of education in Prussian and Russian Poland was foundering amidst a tidal wave of private informal or 'underground' Polish Cultural enterprises. (Davies, 1983: pp.234-235)

Women played a key role in all of these activities. They helped to establish 'The Flying University' where Marie Skłodowska (later known as Madame Curie) gained her education, and the entire network of illegal schools lay in their hands. They supported national movements by keeping insurgents in hiding, protecting the wounded, transporting weapons, munitions and messages and working as scouts and activists. They brought aid to those who had been imprisoned and provided help to the families of arrested men. They delivered conspiratorial correspondence, distributed illegal literature and helped organise meetings. These activities prefigured with remarkable accuracy what they would be doing one hundred years later.

Poland re-emerges

In 1914 the Poles were conscripted by Russians, Germans and Austrians to fight against each other in a war which was not

their own. Throughout the war representatives of various countries made assurances of support for Polish independence, mainly as a way of getting them on their side. With the Western Allies' defeat of Germany, the collapse of Russia and the dissolution of the Austro-Hungarian Empire the stage was finally set for this to happen. Much of the credit for independence goes to Józef Piłsudski who persuaded the Germans to disarm and leave Poland without further bloodshed. His 'War for the frontiers' against the Ukrainian militia in the south-east also ended peacefully. Events took a turn for the worse when in 1920 Lenin's government sent the Soviet army to Poland, as Norman Davies describes "to recreate that Empire in socialist guise, and to spread the revolution to the advanced Capitalist countries of Western Europe" (Davies, 1983: p.396). Despite what could have been at stake for Western Europe, the French gave very little and the British no military assistance. It was purely due to the heroism and military skills of the Poles that the Soviet invasion was stemmed and independence - not just of Poland - maintained.

The period of the partitions had lasted 123 years. But the second Polish Republic lasted only 17 until the outbreak of the Second World War. During this period Poland had enormous problems to deal with, in terms of poverty and unemployment and integrating the country into a cohesive whole. The fact that under Piłsudski's leadership they were able to do so reasonably successfully, and maintain independence and develop their national identity, meant that there was a Polish state *there* to be reconstituted at the end of the second world war.

It was the Poles who then really lost the most as a consequence of the Second World War. The plans which Germany had for Poland make what actually happened look almost as if they got away quite lightly. If the Germans had had their way, Poland would have completely ceased to exist by the end of the war. The plan had been to resettle 20 million Poles in Western Siberia, three to four million would be suitable for re-Germanization and the rest would be annihilated. As it was, six

and a half million Polish citizens, half of whom were Christians and half of whom were Jews were brutally killed during the War, mainly in death camps. The destruction which Germany wreaked on Poland included flattening the capital city Warsaw and ridding it of all its inhabitants, who were either killed or sent to concentration camps, in an act of destruction probably only equalled by Hiroshima.

The brutality of the Germans during the war is well known. What is perhaps less acknowledged is that the death and destruction meted on Poland by the Soviet Army was hardly less abhorrent. Like the Germans, the Soviets classified and segregated the population; but rather than using concentration camps, unfavourable elements were shot straight away. Over one and a half million fell into the category to be deported to Siberia. These were transported and kept in the most unimaginable conditions, and by 1941 over half of them were dead. Fifteen thousand Polish officers disappeared. Over 4,000 of their bodies were found in Soviet mass graves in Katyn; other mass graves have since been discovered, and it can be presumed that the rest met a fairly similar fate. These officers had come from Poland's educated classes, and by killing them systematically Soviet actions appear to have been directed at undermining the possibility of Poland recreating a Polish state. Had Germany not finally attacked Russia it is dubious whether the Polish nation or its population would have survived in any recognisable form. As it was 22% of the total population died. There were one million war orphans at the end of the war and over half a million invalids, and the country had lost 38% of its national assets (compared to 0.8% for example in Britain or 1.5% for France). One can only imagine Polish people's feelings when the Nation was handed over to Stalin at the end of the war.

Poland was placed in the hands of Stalin on the condition that free and unfettered elections were held. Very predictably this never occurred. The period of Stalinization involved violent political repression, an all-pervasive propaganda machine, the

forced collectivisation of agriculture and attacks on the Church. Brutal though this period was it never attained quite the same degree of ferocity which the Stalinist period attained elsewhere. This may have been because the Soviet Union was handed such a battered and brow-beaten Poland that it never needed to use the same degree of force as used to impose Soviet Style communism on the rest of the Eastern bloc. Perhaps the Polish communists themselves in a realistic assessment of people's feelings understood that only so much could be imposed upon the Poles.

It is also the case that as a consequence of their history the Poles have particularly strong feelings about their nation. This must have made Soviet communism with its particular form of internationalism an anathema to even the most ideologically motivated Poles. Whatever the reasons, the Soviet relationship with the Poles was based on a certain degree of interdependency which relied on co-operation from the Polish communists, and in this kind of relationship the weaker party can sometimes call the tune. (Davies, 1983: p.577)

This became much more apparent in 1956 when Gomułka was elected first secretary of the Polish communist party, following riots in which many people had been killed. Gomułka had impeccable credentials and, from the tone set in his inauguration speech, it looked as if things would go very well. He reversed the collectivisation of agriculture with the result that millions of private farms appeared. This was of particular consequence in later years when the ability to acquire food from farmers through the informal economy provided an alternative to dependency on the state. He also released Cardinal Wyszński from his three years internment, signaling a far more liberal attitude towards the Catholic Church.

Throughout the communist period the Church provided an arena in which independent thought and action could be sustained. Gomułka's apparently more social-democratic approach encouraged people to believe that the party was

willing to reform, prompting a revisionist approach where people believed it made sense to address their grievances to the state. However this appearance of flexibility was pragmatic rather than deep rooted; 'coquettish' as Ost has described it. Behind it there was in fact an increasing tendency towards repression. This became very apparent in 1968.

A new strategy emerges

The six day Arab-Israeli war of 1967 had according to Kasprzyk been greeted with a certain amount of glee: "Our Jews have given their Arabs a drumming" (Kasprzyk, 1997: p.17). This provoked paranoia amongst the elites about anti-Russian feelings, and also stoked their anti-Semitism. It was followed by a period of denouncing the Jews. Things came to a head when a play was closed down on the grounds that it provoked anti-Russian feeling. The students saw this as an attack on their freedom of expression, and a mass demonstration was held. As a consequence of this the party launched a very heavy attack on intellectuals and Jews. Jews were hounded out of their jobs and asked to leave the country. This was also used as an opportunity for the party to rid itself of its more liberal elements, since the non-Jews who protested at what was going on were also very swiftly replaced. Students were expelled and professors lost their jobs. The viciousness of the campaign and the persecution of thousands of law-abiding citizens dashed all previous hopes that the state was capable of reform. This was confirmed even more brutally in the strikes of 1970.

In response to an ever worsening economic situation Gomułka raised staple food prices by 36% - incredibly just two weeks before Christmas. This inevitably resulted in an earthquake of working class protest, and in Gdańsk thousands of workers marched on the Party's regional headquarters demanding the increases be withdrawn. Armed police and professional Polish soldiers were ordered to crush what Gomułka called a 'counter-revolution,' and hundreds of Polish workers were killed.

With hindsight it is possible to say that 1970 was a key step in the formation of Solidarity. Many of those killed came from the Lenin shipyard, where the initial 1980 strikes later broke out, and it was the drive to preserve their memory which helped to fuse the workers into a cohesive whole. It also led to the formation of the strike committees which subsequently campaigned amongst other things for free trade unions. Also, as David Ost explains, 1970 put the final nail in the revisionism coffin; if the opposition were going to get anywhere they had to look for an alternative approach.

> The opposition now felt that it had absolutely nothing in common with such a party, and there seemed little point addressing democratic demands to it. This was the turning point. The revisionist strategy broke down. If the opposition was unwilling to succumb to pessimism and despair, it had to find a new strategy. It had to embrace a new theory of politics and a new theory of democratization" (Ost, 1990: p.53)

Intellectuals like Zygmunt Bauman, Maria Hirszowicz and Leszek Kołakowski who left Poland following events in 68, set about devising alternative strategies. However it was Kołakowski's *Thesis on Hope and Hopelessness* which most clearly articulated the new approach. This was based on the idea of a clear separation between realms; between civil society and the state. Reform was something the state did, while resistance emerged from the society. The state might be unwilling to reform, but its continued monopoly depended on the absence of resistance. So to the extent that the population resisted the system could be undermined. And this resistance was broadly defined:

> Since the tendency of the state socialist system is to monopolise public life, to destroy all independent forms of social life ... then any form of independently organised social activity constitutes resistance to the system. Any sustained resistance counteracts a

fundamental principle of the state socialist system and thus constitutes a de facto reform of the system. Thus, reform is possible through independent social activity - that is, through an independently organised civil society. (Ost, *op. cit.*: p.62)

In some ways resistance had been a continuous feature of the system. Most of my informants had participated in some kind of activity of this nature, whether it was spraying graffiti on the walls, building a wooden house for students to meet up in the Bieszczady forests, organising catechism classes after school, joining sit-in strikes whose effect never extended beyond that work place, actually trying to achieve things within one's legal union or participating in illegal ones.[1] Perhaps one could even dignify the supreme lack of effort people put into their work as constituting a very subtle form of resistance. It certainly had that effect:

> The so-called 'specific conditions', often darkly hinted at in official apologias for the underperformance of the Polish economy, are mainly social and political in character. They refer to the historic, and apparently incurable alienation of most people from the state, and from the state-owned enterprises by which almost all of them are employed. Throughout the wars and partitions of modern times, Poles have been taught to pay authority as little respect as necessary, to slack and to cheat in their dealings with public concerns, and to reserve all their energies for the pursuit of the private welfare. They are instinctively 'agin' the system. As a result, bureaucratic controls proliferate, a management vainly opposes the ingrained habits of an endlessly ingenious workforce. Low productivity, shoddy standards and gross inefficiency often appear for no

[1] See Appendix B, Interviewees 15, 7, 14, 12, 18, and 8.

sound technical or economic reason. (Davies, 1983: p.597)

Even the Polish communists themselves appear to have been involved in subverting Soviet central orders, whether this came from their own reservations about the Soviet system or was motivated by a clearer awareness of Polish realities rather than a desire to resist in itself;

> Behind the scenes, the native communists of the PZPR fought a steady rearguard action against the Soviet stooges in their midst. They protected the comrades who had fallen into disfavour, and blocked any moves towards wholesale revenge. Show trials were never adopted as an instrument of policy. ... Fraud and chicanery were widespread. But violence was not. ... The Church, though assailed on all sides, was not, as in Bulgaria or the Ukraine suppressed ... the peasants, though deprived of legal claim to the land were not deported..." (Davies, *op. cit.*: pp.581-582)

Timothy Garton Ash makes the same observation. "Even in the worst years of Stalinism, Polish communism was distinguished by half-measures, partially executed". (Ash, 1991: p.10) All this meant that there was a very specific 'Polish Road' to communism, the path of which was determined by the ingrained nature of Polish resistance. Writings like Kołakowski's simply gave it a much more self conscious form.

Kołakowski's ideas really emerged in practice following events of 1976. Gierek, who had taken over from Gomułka after the strikes in December 1970, had tried to win the support of the population by bringing them 'a steadily rising standard of living as well as the socialist advantages of full employment and social security'. But by now Poland was waist deep in debt and was failing to come up with the goods. In 1976 there was another attempt to raise prices, and although it was more tactfully administered, strikes inevitably occurred. The regime capitulated

to strikers demands without the levels of violence which they had applied in previous years.

However in Radom many workers were put on trial for their alleged actions during the strikes. Many of these workers did not have the resources with which to defend themselves and a group of intellectuals set up The Workers Defence Committee (KOR) to try to fulfill this role. KOR's aim was to make public all cases of abuse and repression against the workers who participated in the strike, and bring the legal system to bear on them. One of the defining features of KOR's strategy was that instead of addressing its grievances to the state authority, as oppositionists had previously done, it concentrated its efforts on *society* as a basis for resistance. (Ost, 1990: p.11) So for example they founded an unofficial paper, 'The Worker' (*Robotnik*) which was the first step in a huge circulation of underground publications which proved to have such a formative influence in later years. The first unofficial free union cell was formed on its initiative, and others appeared subsequently. KOR was accompanied by the development of other informal social organisations, and whether or not it was directly inspired by Kołakowski it provided a practical example of his ideas.

Another important dimension to the formation of Solidarity was the visit in 1979 of the new Polish Pope. The church had always played a very important role for Polish people, and over the past 200 years provided a physical and metaphorical 'space' where their identity and values and sense of themselves as a Polish nation could be preserved. This was as valid in 1880 as it was a hundred years later. On the whole the communists tolerated the Church. This was the only sensible way of dealing with it since periods of persecution only served to increase its esteem. The Church during these years was gifted with two outstanding personalities, the Primate Stefan Wyszyński and Cardinal Karol Wojtyła who later became the Pope. These two men ensured, with the help of many others, that the space the Church had been permitted was used to maximum effect.

During these years philosophers and writers congregated around the Church and helped to develop a new Catholic social philosophy which merged with the political strategy that the Church had developed to deal with living under a totalitarian regime. It also went through a process of rapprochement with the Left. Then in October 1978 there occurred what Timothy Garton Ash has described as, 'A shocking external intervention in the internal affairs of People's Poland'. Cardinal Karol Wojtyła was elected Pope. Karol Wojtyła was the first non-Italian Pope in 500 years, and that a Pole should have been elected was regarded as little short of a miracle. The impact which his visit had on the nation was tremendous. Many of my respondents talked later about its significance for them, atheists and Catholics alike. In terms of its role in the formation of Solidarity, Timothy Garton Ash describes the form this impact took:

> There is no doubt that the communist 'power' was heading for a crisis anyway: the nosedive was going to end in a crash, another attempt to increase food prices was almost certainly going to produce another explosion of working-class protest. But the form the explosion took in 1980 – the quiet dignity of the workers, their peaceful self-restraint, the rhetoric of moral regeneration, the ban on alcohol, the breadth of spontaneous social support – this follows from the mass experience of that fantastic pilgrimage in June 1979. It is hard to conceive of Solidarity without the Polish Pope. (Ash, 1991: p.33)

Solidarity emerged out of strikes in August 1980, and its achievements defied anything which could have been predicted, or even imagined. During the year and a half Solidarity was permitted to exist, before the imposition of martial law, Poland moved from a society in which every little detail of everyday life was controlled by the state to one in which well over ten million people had joined a free trade union movement which effectively gave them the potential to have considerable

influence over the public sphere. While the immediate cause of Solidarity was a rise in prices and various workplace issues, its roots lay very much deeper. I have tried to cover a few of them here. The wish to commemorate the workers killed in 1970 provided a groundswell of demands upon the state, and the request for a monument was one of the first of many to which the regime capitulated. KOR, the vast array of publications it stimulated, social networks and unions it precipitated provided in a sense the vehicle which enabled Solidarity to develop. However underlying and essential to all of this was the degree of alienation people felt towards the regime:

> All the unreal 'representative' structures of the state, all those intermediate organisations through which a totalitarian regime attempts to control, mobilise and (if it is wise) consult its citizens – the Party, the youth movement, the official trades unions – these were subjects of indifference or contempt. (ibid: p.30-31)

This led to a situation in which people focused more and more of their energies onto the private sphere.

> Their attachment and fierce loyalty went first to the family, second, to a close circle of friends, and, third, to what Wałęsa would describe as 'the family which is called Poland' – the nation. (ibid: p.31)

Where KOR had merely trodden on the toes of the state authority, Solidarity, in a process which paralleled that described by Habermas, challenged it with the *fait accompli* of a rapidly constituted, fully-formed public sphere:

> 'The renewal' that swept through Poland affected not only the political system, but also economic management, the arts, the media and the Church. Censorship was relaxed, at first spontaneously and unofficially, then legally with a new censorship law in the fall of 1981. The freer atmosphere in the press

> allowed a remarkably open discussion ... The movement
> toward a more open official press was accelerated by the
> enormous quantity of unofficial publications ... which
> were completely free of censorship ... The increased
> availability and diversity of information and ideas
> stimulated public discussion and popular participation in
> the political arena... (Mason, 1985: p.244)

The idea which I develop in this study is that it was the strength
of this private sphere, and the social cohesion resulting from it,
which enabled people to constitute a civil society so rapidly. The
whole range of activities which people engaged in, the
discussion clubs, political forums, independent social
organisations were not a just means to an end, but also an end
in themselves. (Ost, 1990: p.31)

In the face of a system which tried to control the public sphere,
the emergence of these spontaneous activities from the private
realm did, as Kołakowski predicted, effectively challenge the
whole dynamic of the society.

Martial law

All this meant that society had taken control in Poland as a
whole. But Solidarity itself, partly compelled by the
requirements of having to negotiate with a highly centralised
authority and partly because of the character of Wałęsa, had as it
evolved become a highly public and centralised mass movement,
with a strong and conspicuous leadership.[2] So when Jaruzelski
imposed martial law in 1981, leading to internment of all the
potential or actual public figures and cutting off all means of
communication and publicity, the state was able very swiftly to
re-appropriate the public sphere.

[2] The way in which the Solidarity Leadership came to reflect the
structures of the party is dealt with by Staniszkis (1992).

The extent to which Solidarity had come to depend on a co-ordinated leadership was reflected in the disorganised response to the military crackdown. Many workers could not strike because when they came to work on the Monday morning they found the military had arrived there first. Others struck for about a week, but left to be with their families on Sunday. Returning a day or two later, they would find the plant under military control, the key leaders arrested and no one ready to organise anything. According to the official press, protests took place in 180 workplaces on December 15. But this steadily declined to six factories by December 20. Solidarity was so committed to free and open communication that when that communication was blocked, the union could not offer any reply.[3]

There was little overt political activity directly after the imposition of martial law, with no demonstration of support until the celebrations on May 3. The forceful and often brutal reaction of the police to these demonstrations dampened people's enthusiasm for this strategy of protest, and the risks involved meant that fewer people participated. Soon people gave up on public protests, many went through a process described as *internal migration* and started to create an alternative public sphere underground.

The next chapter will be devoted to providing a portrait of women's central role in that movement. Because of their firm location in the private sphere, women were well placed to play a unique role in the Underground, and an exploration of this role provides insight into the working of the Underground as a whole. The chapter will look first at the Underground in its historical context as understood by women, and then at the way in which the traditional roles and characteristics of women were particularly well suited to activity in it.

[3] See Ost, 1990: p.150; & Mason , 1985: p.218.

Following this it will explore key areas in which women were active, and consider some of the factors which limited their activity.

The study and its limitations

My research is based on 21 in-depth interviews with a random sample of women from the Warsaw area, plus an examination of background materials on the Underground. Due to the small scale of the research the findings will be presented more as suggestions or hypotheses for testing than demonstrated conclusions. By its nature the research also has some other limitations.

In the first place, not only were these activities of women invisible to Polish society, academics and journalists, they were also largely invisible to the women themselves.[4] Thus one of my interviewees, on being asked what she did after imposition of martial law, said that she "did not do anything". On further prodding it transpired that, "I engaged myself with various Underground activities; I was a 'connector'. I found flats for people who had to hide, I made a bulletin the same style as I had done under KOR..."[5] As Barbara Labuda has explained, women often simply did not realise the significance of their activities" (Penn, 1993: p.7).

Part of the reason for this seems to have been the naturalness of an activity which rendered it invisible. "People did not think that they were connectors, they just carried letters and afterwards

[4] Penn, S, (1993) "The National Secret". Original manuscript seen, which was due to appear in *The Journal of Women's History* (1993), Autumn Issue. For example she quotes US journalist Weschler " 'in the same eerie way that a farflung colonial outpost...managed to produce a generation featuring the likes of...so Poland in the 1970s and 1980s had produced,.....' Weschler did not name a single woman".

[5] Interviewee no. 10

thought about what they were doing...You did a lot of things which did not have a formal name or expression." As one of my interviewees explained, "It was so natural it did not have a name". The invisibility was reflected in the absence of a name for it.[6] At a practical level it is difficult to find out what someone is doing if they don't see the significance of their activity themselves.

Material was rendered further inaccessible by the conditions of conspiracy itself, which required that a person know as little as possible about the process which they were involved in, and who *else* they were involved with. This was in order to ensure that if they were interrogated there would be no beans to spill. Thus a woman might write a radio programme, but not know by whom it was read and then subsequently broadcast. Not knowing who was 'in the kitchens' (behind the scenes) was a recurring theme in my interviews. But it turned out, in keeping with the gendered nature of the expression, that it was frequently women who were doing it.[7] This need for ignorance also meant that women would try to forget things as quickly as possible. "Today I don't remember... I would try to forget things straight away. Who was arrested where and how ... I threw it out of my consciousness, so today I don't remember the details."[8]

A bias is introduced into the work by the fact that all of the interviewees, except one, are highly educated women. The reason for this is that none of my interviewees, even those who had been highly involved with workers, still had contact with that *środowisko*. This seems to be a consequence of the growing gap which developed between the workers and the intellectuals in the later years of the movement. One of my interviewees explained how, despite her best efforts, her previously warm and friendly relations with the workers had ceased. She

[6] Interviewee no: 9
[7] Interviewee no: 3
[8] Interviewee no: 9

attributed this to the fact that while she had a chance to improve her situation, they did not. So a great deal of resentment against professional people built up.[9]

This gap is significant for a number of reasons. Firstly a large part of the Underground was about rebuilding union structures from the factory floor level, and it seems important to know what role women played in this. Also not enough attention is paid to the *ciocia revolucja* or what Joanna Sczeszna describes as 'The women of folklore'. These women of seventy or eighty "participated in every mass service for the intention of the free homeland and in every funeral of a well known opposition personality. They sang anti-government songs, they changed the ending of one of the church songs from "Lord, bless our free homeland" to "Lord, give us our free homeland back." On city squares and in front of churches they made floral arrangements in the shape of crosses, of the letter "S" for Solidarity, and of "V" for Victory. The police forced them out and they moved from place to place undefeatable." Their activities also helped to keep the police away from the more serious Underground activities. (Sczeszna, 1990: p.7) Finally there may have been different variables influencing worker participation, for example higher risks of internment or, as one of my interviewees suggested, fewer elaborate social networks, which would have affected women's ability to participate in the Underground.

A further caveat in my work is that apart from an interview with one Underground leader, I have not included any interviews with men. So while gender differences do emerge it is difficult to assess the extent of them. I have no comparative data. One reason why there may be significant differences between men and women is because of the gendered nature of employment in Poland. Thus, for example, many more women are employed in the health and education services, where concern for conditions of society as a whole appear to have taken precedence over

[9] Source - an actress I interviewed; the material was not included in the appendices due to a faulty recording early on in the tape.

personal interests. As Małgosia explained, "That is the motivation for my activity; to fight for something better for all of us; not only for the health service"; and, speaking about today:

> Our activity has many implications. We are fully conscious of the fact that if we want to join Europe we have to be healthy and qualified so most of our protests in the health service are also in the interest and good of our citizens.[10]

By contrast men are concentrated more in heavy industry, where private family-oriented concerns may have been a stronger motivating factor. The nature of a workplace will also have influenced the possibilities for networking; it may have been easier to get to know your friends when working in a school than in a factory. While this is just speculation, the point is a valid one. The work environment is often gendered, so by exploring it one may have insights into the different roles of men and women in the Underground.

Finally I would like to emphasise that the subject of my thesis was the Underground which went into action on the night of the 12th of December 1981. I refer to this as the 'Underground' rather than Solidarity in order to broaden the scope. The Underground movement greatly diversified after martial law was applied, and Solidarity became one of many different strands. Furthermore, not everyone active in the Underground, or even in Solidarity, was a *member* of Solidarity. For as one highly involved participant said, "I was never a member of Solidarity, partly because I wasn't working. But even if I had been working I would not have joined, as Solidarity had a party-like structure".[11]

[10] Interviewee no: 18
[11] Interviewee no: 10

Ch.2
THE ROOTS OF RESISTANCE

When trying to understand the Underground movement, and how 'such large sectors of Polish society could reach similar conclusions simultaneously, organise themselves spontaneously, and co-operate so effectively as to leave Poland's totalitarian system vulnerable to extensive reform', Federowicz concluded that one should turn to 'the unique historical awareness of the Polish nation as a whole'. (Federowicz, 1986: p.3) He is mainly referring here to the way in which the continuity of national tradition 'imparted a kind of cohesion to the otherwise disparate Solidarity movement', (ibid: p.4) a subject well documented by Laba, Tourraine and others.

But I would like here to draw attention to personal history as providing the driving force, as does Laba (1991). I would like to argue that it was this which provided the individual self motivation which enabled Solidarity to sustain itself as a grass roots movement, and for the Underground to continue afterwards.

It was this individual impulse which ensured that Solidarity had no need of a charismatic leader or blind ideology, and that it could not be tamed or appropriated after the tanks had been sent in.[1]

[1] Laba (*op. cit.*: pp.140-144). Like Laba I do not see Wałęsa as constituting a typical charismatic leader. He explains how there is an absence of a leader in the Solidarity iconography, and when Wałęsa is depicted it is "reminiscent ...of characters found frequently in folk mythology, 'the holy beggar, the little tailor, or simpleton who strips off the pretensions of holders of high rank and office and reduce[s] them to the level of common humanity' ".

This came out very strongly in my interviews. Here are some of the replies given by my respondents to the question, "What motivated you to get involved in oppositional activity?"

> I came from that kind of home. My father in the portrait there had been an industrialist before the war. Communism destroyed him. He sat in prison. So from home, really in my mother's milk, I sucked a hatred of communism. This happened in hundreds and thousands of families and afterwards it is reflected in the home... As I grew up I never changed my way of thinking. I had a decidedly anti-communist, anti-socialist outlook on life and my family home was like that so I couldn't be any other way.[2]

> That was perhaps being the daughter of my father and in a sense being situated by the family situation. I was a committed enemy of the state in an automatic way. He had been a spy and from a rich family so our property was confiscated and I suffered from the start.[3]

> I was brought up in the Home Army tradition. Both my mother's brothers were home army officers, and they taught me that activity should be effective, not just get you into prison... My parents were always involved in underground activity. Actually both my grandfathers were exiled to Siberia.[4]

This Underground realm appears to have been in continuous existence in Polish society for a long time, and therefore needs to be taken into consideration in any gender analysis of it. What people did was often seen simply as a continuation of what they or their parents had done in the occupation, and this frequently

[2] Interviewee no. 11 (See Appendix B)
[3] Interviewee no. 14
[4] Interviewee no. 5

provided a reference point or role model for their Underground activities:

> Practically everybody was brought up in a tradition of conspiracy... Since the rebellion in November 1830 there was always somebody who was exiled or something to be done... In the Warsaw homes which didn't burn down during the occupation or uprising there were hiding places which we used during martial law.[5]

> The idea came to our mind immediately to make an Underground structure. During the war and the occupation we did everything Underground; that was normal...and they [the communists] for us are occupational forces. That was normal.[6]

> There was a large group of retired women who worked as messengers. Some of them were experienced guides as they did the same job during World War II. (Sczeszna, 1990: p.3)

History is a particularly rich source of role models for Polish women, who have traditionally played a very important and well documented role.[7] Over half of my informants would draw my attention to this.

> But I found this period of martial law was very similar for me to the period of Warsaw uprising, January uprising, October uprising because we repeated all that was done a century ago. For example I organised here a kind of lesson of history like in the nineteenth century when it was forbidden... There were very few men in this action because men in Poland are for 'big glory'. So

[5] Interviewee no. 5
[6] Interviewee no. 15
[7] See for example Jaworski & Pietrow-Ennker (1992)

this kind of work was what we in the nineteenth century called *praca posytywistyczna*, everyday work. It wasn't very well known, it wasn't something you can describe in history books but it was very necessary.[8]

It should also be pointed out that since more men than women died in the war, and maybe also as a consequence of Stalinisation, today's women have had a more direct role model, their mother, available to them than men. This also emerged in the course of my interviews.[9]

This continuity between the occupation and the Underground was maintained through individual acts of resistance which have been continually perpetrated, but also continually suppressed and kept hidden by the communist regime.

I was a member of the Polish girls' scouts in secondary school which was at first an independent scouts. It quite consciously tried to borrow the pre-war and war resistance structure. Then the communist authorities tried to move against this organisation and take it over ... It was taken over but they never got the structures as they were, we disbanded everything ... Leaving it and moving to the church was also in a sense a case of opposition ... The boys decided differently ...[10]

For me as for many people of my generation the first moment was '68 when there was a student strike; I was in my second year of Slavonic studies. I participated in the strike. Even before it there was a centre for student discussion...it began in 64 - 65. I wasn't yet a student but afterwards when I started participating I found there were strong free political discussions of our situation.[11]

[8] Interviewee no. 16
[9] See e.g. Interviewee no. 18
[10] Interviewee no. 14
[11] Interviewee no. 8

Then in 1970 I was working in a place producing screws actually for the shipyard in Gdańsk and we started to strike... A lot of big firms in Warsaw also went on strike but nobody talks about them because they were internal occupational strikes...and they were only during working hours and apart from that nothing else happened. That information didn't get on to the streets. People who didn't work there or didn't have family who worked there simply didn't know anything about it.[12]

This activity has significance for understanding the role of women in Polish society from a number of perspectives. Any consideration of the participation of women in politics in Poland is incomplete if it does not take into account the role of women at this level. Thus participating in illicit discussion clubs or subversive church activities facilitated a far more potent source of individual expression and influence than the 'filler' seats for women under the communist regime (Nelson, 1985: p.158).

Focusing on the participation of women in formal political structures may be relevant in Western societies, where offices are a source of genuine political power. But it is less appropriate under a communist regime where power was in the hands of a few and where it was the private level which had greater impact on people's day to day lives. While logistics of security for the movement may have prevented this more complete picture being provided under communism, this should not prevent us trying to reconstruct a more accurate picture today.

The continued existence of an Underground sphere over a long period is of general consequence for Polish women. It provides a realm which is free of both the institutionalised patriarchy of the public realm and the private patriarchy of the home, and to which women have unique access because of their special

[12] Interviewee no. 12

connection with the private sphere. This is what I will now go on to examine.

Where Women have the Upper Hand

Publicity was a handicap in the Underground. One KOR activist who had been interned explained that she felt unable to be active on coming out (though in fact she was, but she did not perceive it) and another explained:[13]

> I found flats for people who had to hide...no they didn't hide at my place. My place was very well known, the police were always coming. On the first 10 days of martial law the militia came everyday at different times...[14]

The wife of an activist who was unable herself to participate, because her husband was a well known person, contrasted the plight of Bujak and Frasyniuk with the less well known but maybe more influential *Tygodnik Mazowsze* crew:

> Women were able to hide better. It would have been easier to catch Bujak or Frasyniuk who everybody knew very well, and they had to mainly conspire and it was difficult for them to publish anything because their main requirement was to hide... They [the women] didn't have a public face. They weren't known, and undoubtedly for them it was easier. I think so; they had experience from the previous years.[15]

While the height of Bujak's activity may have been planning strategies for people who didn't listen to a leader, and being shuffled from flat to flat 16 times a month, Łuczywo and

[13] Interviewee no. 20
[14] Interviewee no. 10
[15] Interviewee no. 13

company edited a newspaper which, at its peak in 1985 had a circulation of 80,000 (Ramet, 1995: p.91).

From this perspective Labuda's revelation that she "wrote all of Frasyniuk's speeches; I gave the *Washington Post* an interview in his name", appears self-preserving rather than self-limiting (Penn, 1993: p.7). Women's ability to work behind the scenes enabled them to run the Underground while their male partners sat in prison. A classic example of this is Danuta Winiarska, who for two years organised farmers and workers in the Lublin region under the guise that she was working for a man who was in fact non-existent, Awramczyk. While her actions were motivated by a wish to find her way in a patriarchal society, they were in fact ideally suited to conditions of conspiracy (ibid: p.8). Men wishing to do the same thing would have made themselves into leaders of regional sections and would have been, as they invariably were, caught.

Women's natural conspiratorial talents appear to have been developed into a skill of the highest order and Bujak, who became legendary for the period he spent in hiding attributed his success entirely to the work of women:

> First she is a very intelligent woman, so she was able to make a thorough study of the techniques of the security service... Ewa Kulik is a similar case. Thanks to her intelligence she was able to make a thorough study of the way the security service worked. And it enabled her to get a grip on all the mechanisms related to conspiracy and our concealment. Certainly I dealt with my own security only to a very small degree. Anyway, as a rule, someone like myself who has to go into hiding does not have to answer for his own security. It means that someone else...should answer for this security and create a mechanism of concealment. So in my case and in Wiktor Kucharski's case, Ewa Kulik and Helena

> Łuczywo built all this security system... Zbigniew Jana also depended on the organisational help of women...[16]

While it appears that women were highly skilled in conspiracy, they were also aided in this by traditional assumptions about their role. For example, although the police had heard that *Tygodnik Mazowsze* was a women's paper they couldn't believe it. They kept trying to find its male editor and accusing various personalities of holding this position. Consequently, none of the editors were ever arrested. As Joanna Szeszna explains;

> The police always underestimated women's activity. This was advantageous for us. Two categories of women were, generally, beyond suspicion: the elderly...and the pregnant. During martial law, women from my newspaper editing staff took full advantage of the situation: all 8 of us had 'artificial pregnancies': inside our clothing we carried Underground publications and materials for our weekly. During the winter months artificial pregnancies worked really well. Spring and summer were more difficult as a gust of wind could reveal the true shape of a pregnancy... (Szeszna, *op. cit*:: p.3)

In the Underground context the formal structures, institutionalised behaviour and hierarchy which one associates with men's ways of working are rendered redundant. Whether one can extrapolate from this that women's ways of working are more suited to the Underground remains a point for comparative research.

However, there is a growing body of evidence which suggests that women prefer to work in less structured ways, and this is certainly borne out by material from Poland. Padraic Kenney discusses how it was "the 'un-structured', community-based nature of the strike which forced the regime's reversal", in the

[16] Interviewee no. 22

context of the Lódz strikes 1971 (Kenney, 1995: p.4). And Jancar from her research on women in the Polish opposition concludes:

> She probably favours unstructured, open, and more democratic styles of participation rather than the traditional organized hierarchies. In her role of spokesperson she tends to make symbolic emotional appeals rather than rational functional demands (Jancar, 1985: p.184).

Part of the reason why women apparently are so adept at functioning in an unstructured way may be because of their strong networks among friends, family, neighbours and colleagues from work. Women's childcare responsibilities may put women in a position where they have more contact with other families in the neighbourhood and more contact with their own extended family. Furthermore women's concentration in the caring professions may give them more contact with a wide range of people than men working in an industrial context - who see the same faces day in and day out.

On top of that, the fact that women all over Poland have the same primary duties of care for the home and family, and the same identity of *gospodyni*, may provide a commonality, which facilitates communication between women. While the research required to demonstrate this is beyond the scope of the current thesis, it did emerge in the interviews that women had highly developed networks and that these had an absolutely crucial role in a period where all other forms of communication were either unavailable, or were heavily monitored by the security services.

Finally I should mention that women do appear to have been stronger psychologically than men, and more resistant under interrogation:

> There were many women who were in the Underground. Generally women are much more

> psychologically strong than men... Women are forced to
> fight for everything, they are generally braver with few
> fears. Women were more stubborn under interrogation.
> Many men were afraid for their children and families;
> you could seldom frighten a woman.[17]

While this may sound like a somewhat one-sided portrayal,
further testimony to this was provided by a woman whose legal
work involved her in reading a lot of the legal documents
surrounding a person's internment. From this evidence she
concludes that:

> Women are psychologically stronger, in spite of family
> matters. In spite of the specific forms of repression they
> were able to be stronger under interrogation...women
> behaved far more decisively; 'I won't tell you, it's not
> your business and that's the end of it'.[18]

This is despite the fact that women were far more likely to be
blackmailed than men (Sczeszna, *op. cit.*: p.4).

Women's Roles in the Underground -

Next I will try to categorise some of the wide variety of ways in
which women put their particular talents, outlined above, to the
service of the Underground.

- Organisation

In Polish 'behind the scenes' is translated as 'in the kitchen'. In
Poland women are 'in the kitchen' from the lowest to the
highest levels, creating a supporting structure for the public
world and making sure that everything goes smoothly:

[17] Interviewee no. 15
[18] Interviewee no. 12

Everybody had to put his skills to use, so I went to the place where they were organising and asked how I could help and since they know my work from the hospital or the parish or both places they would ask me if I could do some typing, or write a protocol for their discussions with management. So from the beginning I started simply doing things and left everything to continue...and then the idea came from Warsaw or Gdańsk that there should be advisers to the workers' committees. But I was never an adviser in the sense of some people here. I went on typing and writing protocols and participating in meetings... It was more than a normal trade union because society was so destitute...everything was needed, milk for the children and how to divide this milk so that it doesn't become insanitary and all such problems. I was there rather as an adviser on how to put milk into plastic bags than at the highest level of politics.[19]

Men were leaders of the Underground and that's a fact. But really women did the dirty work - carried things, ran around to the houses of families [of the interned] organised parcels, produced sausage. Our stairs smelt like a butchers shop; *Kiełbasa* for the revolution![20]

Part of this 'dirty work' was the organisation of TKK solidarity. This operated on the basis of a network of specialised cells the most important of which was 'the bureau', which kept track of the whereabouts of Solidarity leaders and newspaper editors, and co-ordinated contacts between other cells. The cell for interregional contacts handled correspondence and materials between the regional commissions. An information cell maintained a file of useful information including for example the names and addresses of people whose apartments could be used for meetings. There was also a financial cell, instructions

[19] Interviewee no. 14
[20] Interviewee no. 15

cell, legalisation cell and a special cell which maintained a communications system independent of state-owned telephone and telex systems (Ramet, 1995: p.75).

The suggestion is that women were crucial at this level and according to Barbara Labuda, "Men didn't have the skills to manage the Underground" (Penn, 1993: p.7). As Shana Penn reports:

> The women 'chiefs', as Labuda called the regional organisers, established the union cells and training centres, attended secret meetings, arranged for the transfer of money, found contacts at Western embassies, spoke to the press, and developed relations with local and foreign clergy. When Solidarity members needed aid, they came to the women (ibid).

Bujak seems to agree;

> In this sense they were engaged first in organisational matters.. and if I understand, its essential side. I think it's not a coincidence that many of the organisational matters related to paperwork were in their hands. It required a great accuracy, precision, a real thoroughness in work. Enormous reliability. [21]

And while "Barbara Labuda played an important role in Wroclaw, where she answered for all the organisational matters and for the 'counselling' of Frasyniuk, drafting our documents, our statements", it seems that "This legendary hero [Frasyniuk] was watching football games on TV while I [Labuda] was doing all the work" (Penn, *op. cit.*).

- Contact Services

The head of the bureau for inter-regional contact told her story.

[21] Interviewee no. 22

My friend came to the house of my parents and said that he had a hidden 'Lis' [fox] and he would like me to find Bujak, and I found Bujak, through my friend. That was in January [1982]. And in January I started to work for some firm for funny money just so that I would be formally employed and look less suspicious... At the beginning I was a connector between Lis and Bujak then later when they had shut down the connection between regions I became the chief of the contact bureau between regions. And that was the structure which arranged contacts between the members of TKK. I depended on girls who travelled with these letters and travelled all over Poland ... they were people who I knew directly, my friends from school or study, people who I could trust ... I used to say this is a very important letter. It needs to get there today not tomorrow. I was never let down.

She went on to explain:

I thought it was safer to use girls. Girls are quicker, they deal more easily with conflict. Men were immediately suspect. A girl was able to disguise herself by carrying a kilo of apples ... that old lady carrying a kilo of potatoes might have pamphlets in her underwear .[22]

While men were imprisoned by their public status, women kept a network of information circulating through family, friends and friends of friends. This was facilitated by the fact that they were less suspicious in the eyes of the police, maintained contact through 'family help', and were predominant in services, where work was based on relations between people, rather than in industry where the relationship was between people and things.

[22] Interviewee no. 9

The health service was of particular use in maintaining contacts because even at the height of martial law, the emergency service was one communication network which they couldn't shut down.[23] Women were also able to form a national network of sorts through their time in internment:

> There was a mixture of women from all over Poland; from various regions. This had the overall meaning that we got to know each other in a way that now wherever I go there is always someone I know from Goldap. Now why do I mention this? It had an influence on the efficiency of the Underground's action later. We had contacts everywhere and we could be sure of them because we had seen how they responded to extreme conditions; we could count on each other. Apart from that we handed press and information to each other... Men were in different internment centres divided regionally so they couldn't set up the same networks; They didn't know each other on the scale of the whole country.[24]

- *Flats*

The Underground was physically located at the most private level of society; people's homes. These were used for:-

hiding people:

> What all this security [hiding Bujak] relied on was a great number of flats. We had to have at our disposal a great number of flats which we could change and in which we could live. As a matter of fact, all this housing structure, so called *mieszkanówka* was organised mainly by women and mainly through using some connections which were considered women's... On the premises of a single

[23] Interviewee no. 15
[24] Interviewee no. 12

housing estate we needed 16 flats in one month for the efficient and safe functioning of this structure. One needed a great number of these flats and it could only be done in an efficient and reliable way by women.[25]

hiding the press:

The editors of *Tygodnik* were based at my flat [her husband by the way had been a high up member of the communist party]. The editing office wandered and for a few years it was at my flat.[26]

concealing culture:

I had a big house where if I put two rooms together it could be used as an illegal home theatre. I held a few performances here as well as concerts, art exhibitions and film showing.[27]

and hiding the Solidarity organisation:

We opened a nation-wide structure. It was all in private flats. People gave us empty flats.[28]

The ultimate responsibility for this lay with women:

It was always a woman, it seems, who was responsible for the decision - very crucial for our newspaper - whether to let us use her and her family house or apartment for our work - printing, editing, for meetings, for storing things and so on. Decisions were obviously made by the whole family, but a woman's voice was always the most important. We never used anybody's

[25] Interviewee no. 22

[26] Interviewee no. 8

[27] Interviewee no. 2

[28] Interviewee no. 15

apartment without the knowledge of the hostess, although we did use the house without the knowledge of the host. (Sczeszna *op. cit.*)

- The press

> The importance of Underground publishing for the maintenance of parallel society should not be underestimated. Underground publications were the vehicles for self-education, the arenas for strategic and tactical debate, and the conduits for news and useful information for everyday life. One can safely say that without Underground publishing there would have been no parallel society. (Ramet, 1995: p.90)

The press was very extensive in scale, and it has been estimated that about 1,100 - 1,300 periodicals appeared in Poland between 1981 and 1986. About 20 percent of these were weeklies, another 20 percent bi-weeklies and perhaps about 35 percent were monthlies. The rest were bi-monthlies or quarterlies. The conditions for the maintenance of the Underground press were extremely difficult. Immediately after martial law telephone lines were out for four weeks and openly wire-tapped for nearly a year after that. Letters and telegrams were censored and one needed special police permission to leave one's home city. The publication of newspapers and magazines was suspended; there were strict restrictions on the use of photocopying machines all of which were locked and sealed in the first few months of martial law (Ost, 1990: p.153).

Participation in some of these activities could provoke a prison sentence or confiscation of one's home if a printing press was found there.[29] Sustaining a normal press is a very large task. Sustaining an Underground press in these conditions was huge. Paper and ink had to be obtained, and in the early days everything had to be typed. Information had to be collected

[29] Interviewee no. 3

despite the lack of communications. Above all the newspapers had to be stored and distributed in clandestine conditions.

These were the tasks, almost exclusively, of women:

> The Underground press nearly supported itself. Do you know how expensive paper is? We took our back packs to a little shop in a little town and we bought that paper. The woman in the shop knew that the co-operative didn't really exist but she sold it to us... People collected, stole paper from work. Paper, machines, dye, it was all a great problem.[30]

> I produced a bulletin for the regional newsletters of Solidarity which went to regions all over Poland... it provided information about repression. Various kinds of information found their way to me and I made a bulletin the same style as I had done under KOR. That would go to various parts of Poland, there would be a few dozen copies; it was a bulletin for the editors.[31]

But there were drawbacks:

> Printing: I haven't heard of that being done by a woman; that was very hard physical work in very bad conditions; either in cold cellars or in light camping houses where you couldn't turn on a light and where there was only cold water.[32]

And so:
> In the severe conditions of martial law everything was done on typewriters. Everybody typed on machines. If anything that's the work of women not men.[33]

[30] Interviewee no. 13
[31] Interviewee no. 10
[32] Interviewee no. 10
[33] Interviewee no. 17

After typing the material had to be stored:

> At this time I ran a wholesale storage of newspapers.
> My friends took illegal stuff from the printers and
> others came. It was one of many wholesalers. It wasn't a
> very big quantity. I might have had 1000 pieces of
> *Tygodnik Mazowsze* but 100 pieces were difficult to carry.
> No one took 1000 pieces. It went from hand to hand
> and depended on trust otherwise we'd all go to
> prison...[34]

> I was very busy distributing leaflets. Sometimes I would
> put them in Kuba's sweater and just hope they wouldn't
> fall out.[35]

However the most important aspect of the Underground was
Tygodnik Mazowsze, without which:

> The Underground could not have existed. It was a
> forum in which political opinions and declarations could
> be made - a sign of stability. It was a link among people
> in finding sympathizers at a dangerous time when
> people were dispirited (Penn, 1993: p.6).

This was:

> Entirely in the hands of women. This means that the
> main paper of the region, but in fact the main national
> paper i.e. *Tygodnik Mazowsze* was organised by a team of
> women.[36]

[34] Interviewee no. 9
[35] Interviewee no. 3
[36] Interviewee no. 22

The Primate's Committee [37]

This had a vital role in counteracting the state's attempts at coercion:

> Then, when martial law came the church came to play a very good and very important role in one thing which is absolutely crucial to this day. It did not happen in Poland what happened and still happens in the Soviet Union: the victims were not isolated. That was not allowed by the church. The communists couldn't make the people in internment something dangerous to contact or mention. That was their original intention but it didn't work.[38]

> And it worked on publicity, that was the main weapon with which we fought so that people would not be left alone. We made sure it wasn't as in Russia where someone could disappear and no-one know what had happened to him; we tried to make sure that it wasn't like that. Straight away we called a press conference with the West and gave their names however small the town they were from.[39]

While the Church gave the activity an institutional form, the 'we' were women:

> It was mainly women who worked there. They went to the prisons and took packets to the prisons and helped the families of those interned. These women worked exceptionally well and their work was incredibly

[37] 'The Primate's Relief Committee for People Deprived of Liberty and for Their Families' was established in 1981 to organise aid such as food and medical supplies for political prisoners. See Ramet (1995: p.159).
[38] Interviewee no. 14
[39] Interviewee no. 16

necessary because it was for the families of those interned...[40]

St Martin's would try straight away to check where children of the interned were and make sure that they were being looked after. We would try straight away to make sure that the children were safe and that nothing had happened to them.[41]

I was not just helping but also keeping in contact on behalf of Solidarity as such. My function was to visit some people who had no other visitors, partly for humanitarian reasons but also to keep them in contact with the organisation; bringing letters, information communication and so on. So that involved travelling all over the country because they were interned in different places... [42]

We collected money from people. This money was directed to helping the families of those interned, their wives and children. There were also the lawyer's fees.[43]

We found lawyers and made arrangements for them to represent people before they were interned.[44]

The work which they did has had lasting consequences:

We have since then fought a great deal for prison conditions. The health service made a report of prison conditions which went to Amnesty International. All reports of arrests went to the Primate's Committee. This huge documentation went to Western organisations and

[40] Interviewee no. 17
[41] Interviewee no. 19
[42] Interviewee no. 14
[43] Interviewee no. 20
[44] Interviewee no. 20

created pressure because subsequently various representatives [from these organisations] came. Previously there had been no priests in prison and we organised that. ...We fought so that prisoners who had to undergo serious treatment could be operated on or treated in a normal public hospital. That bore fruit a while after freedom had already been obtained.[45]

The Journalists Association

Not all independent associations arose on independent initiative; some were outgrowths of official associations which refused to knuckle under in 1982. An example of this was the suspended Journalists Association which early in 1982 issued the following guidelines to its members:

> If you can continue your journalistic work in the way you did before martial law, do so without bad feelings; your audience will back you up. If you praise martial law and try to win for it social acceptance, if you attack those who cannot defend themselves, if you provide false or biased information...be sure that you will lose face and your reputation in the eyes of your audience... Besides, don't be surprised if you'll have to face consequences one day. (Ramet, 1995: p.87)

When the regime dissolved the original Journalists Association and replaced it with the Association of Journalists of the People's Republic of Poland only 40 percent joined the new association. The rest lost their jobs and the suppressed Journalists Association continued its work underground. While I could not ascertain the relative proportions of men and women staying with the official organisation, it did emerge through my research that the networks and support systems which enabled the dissenting journalists to carry on their activities, outside the official system, were run almost exclusively by women:

[45] Interviewee no. 15

It was the most important publisher; it published a great many titles and it was financed by the party... So a great many people were without work and without a means of holding life together so a 'friendly help' [feminine gender in Polish] arose and I was active in that and in this neighbourhood, *Powiśle,* I had a group under my care. So we found out from the administration who had lost work and who was suspended ... and we made a list of those who were 'released' from work as a consequence of verification. Then I made this questionnaire for people under my care: 'When were your last earnings, how many children, for how long have you not had any money?'[46]

I gave people food and medicine rather than Underground newspapers. We had at home all the lists of people needing help. We organised a system of dividing all these goods. There were very few men in this action because men in Poland are for 'big glory'.[47]

A priest at St Anne's lent us a cellar. Lorries came from Holland, England. *Medical Aid for Poland* was a big help.[48]

So it was necessary to have a cellar in a church...where we could store these boxes, because you see there were a lot of goods and our apartments are too small.[49]

It went to the church where there were catacombs. A lot of clothes and food packets and when it was a holiday we made packets for everybody on these lists...there was a whole team, six or ten people

[46] Interviewee no. 17
[47] Interviewee no. 16
[48] Interviewee no. 17
[49] Interviewee no. 16

downstairs. We had afternoon shifts in the catacombs so people would come for clothes. Often we worked until late into the night... I worked there maybe every day [for many years]. Even when I had employment I worked there. There were some men but mainly women. If somebody was too ill or too old to come, women would choose the things and whoever had a car would go there. In that cellar it was mainly women but sometimes there were men because it was necessary to carry heavy things.[50]

The Second Economy

Life was extremely difficult:

> Really it was a very difficult period because we were hungry; simply we were hungry because it was impossible to have money and impossible to sell something and because we divided these goods it was impossible to take them because there were always more people in worse conditions than ourselves. [51]

> And everyday life was difficult, very difficult, you have simply no idea.[52]

However it is a tribute to women that it was never incapacitating:

> From an old skirt you made trousers for children and so on. Our innovation was huge... of course the innovation of women.[53]

[50] Interviewee no. 17
[51] Interviewee no. 16
[52] Interviewee no. 17
[53] Interviewee no. 16

It was a very difficult time. My husband worked in a state firm. I am able to knit. I knitted sweaters at night. I couldn't go to work because there were two children at home. For a long time I knitted and sold them through friends and family. I made some for friends and family who live in Austria.[54]

I received a little money from grandpa, a little from my husband [she is separated], but I lived mainly by making jewellery well into the night. I didn't accept the help I was offered because I felt I couldn't pay it back.[55]

I was very careful, very; I didn't buy any clothes during those years [1980 - 1989], neither for me nor my daughter. The custom was to hand things from one child to another. For many years I didn't buy anything, but my daughter was very well dressed. Really there was nothing in the shops ... I would try to buy tea for myself and for her I would always try to get something good, ham, white cheese ... We really spent very little on food.[56]

Throughout the communist period the second economy assumed a far greater importance than it normally does in Western societies. However during the Underground this involvement in it turned into a dependency, as people developed their entrepreneurial skills, relied increasingly on the private distribution of peasant produce, either through friends, family or church institutions, and on finance and supplies from the West.

Not only were women very often the initiators of entrepreneurial activity, but as can be seen from the example of the Journalists Association, one in hundreds of similar groups,

[54] Interviewee no. 18
[55] Interviewee no. 7
[56] Interviewee no. 10

the key to redistribution lay in their hands. This not only weakened the state's already weak control over the economy; women's appropriation of economic mechanisms weakened male authority in the private sphere. This may have further increased women's possibilities for participation.

As can be seen from the above analysis, women's fluency in the private sphere meant that it was women rather than men who had the skills necessary to organise an Underground structure. Their hidden role enabled them to organise Underground structures not only unbeknown to the authority but maybe on occasion unbeknown to men themselves. Their networks of communication replaced those which the authorities had shut down. Their intimate knowledge of each other's families and private circumstances enabled them to create a network to meet people's needs. Their control over flats and connection with the church enabled them to create a physical location for the Underground.

Last but not least, mention should be made of the role which women played, in maintaining, against all odds, the family as a social institution. As Kamiński explains, "If family ties are defended, other forms of Solidarity can develop within society but outside the realm of the state". Thus, "The family may be the last line of defence, but from that trench offensive actions can be mounted" (Kamiński, 1992: p.253). While husbands were in hiding or in prison (or even at home), women ran the domestic sphere.

Ch.3
WOMEN AND THE PRIVATE SPHERE

Women not only provided the supporting structures which kept an Underground running, but in both the legal and illegal period showed considerable initiative in setting up new union structures and initiating other activities. Possibilities for showing initiative were extremely limited under the communist system in general, but possibly even more limited for women who, being restricted to the lower echelons of the hierarchy, were less frequently in decision-making positions. However at the onset of Solidarity and during the Underground period, when the rules and institutional structures which usually work against the interests of women were not yet in place, women often acted in a decisive and effective way. As Joanna Sczeszna explains;

> The structures of the Underground were less formal than those of the state or the government. This is the reason that women occupied important positions according to their qualifications, talents and level of involvement in the Underground, but not in official structures. (Sczeszna, 1990: p.3)

Here are some examples of the kinds of activities which women would mention:

> I was a co-founder of Solidarity in my place of work. I organised the first meeting in my place of work to establish just how many people want to join. A huge number came, there were 120 in the room; people were in the corridors, on the stairs. [1]

[1] Interviewee no. 11

When the strikes broke out I was working at a printers and I gave up my job because I wanted to be there at the shipyards, so I resigned from work. I was the main writer for the bulletin *Stocznia*. [2]

When martial law was imposed theatre became really senseless. For example I found myself acting to an audience of soldiers and so I left ... I was living in Ursus at the time and I wanted to do something more, so I went along to the factory and explained that I was an actress and would like to help in some way. ... I started acting out verses and forbidden plays and that sort of thing. The workers loved the theatre. The theatre was held literally underground, under a church. Eventually it developed into an important Underground theatre in that I got many distinguished actors out to Ursus to act there. [3]

I specialised in organising the Underground administration for the whole region. I was also the chief of two Underground magazines in Poznań. ... I travelled all the time... I was responsible for the distribution of illegal newspapers all over Poznań. ... I often travelled to Warsaw. We worked 24 hours a day. We went on Saturday and came back on Sunday. It's safer on the railway for a woman like myself. I had a nickname 'Aunt of the Revolution'. [4]

I was very unhappy when martial law was declared. But one day I got a packet of coffee and it made me feel so

[2] Interviewee no. 10

[3] Interview with an actress, who gave up the state theatre to participate in the Underground. This has not been included in the main group of interviews because of a fault in the recording which occurred early in the interview.

[4] Interviewee no. 15

much better. I stopped being afraid and thought if one packet of coffee could have such an effect on me maybe I could do something similar. ... I set up an agency for the unemployed. I ran an employment bureau for people thrown out of work at the church for the illegal Journalists Association, St Anne's. I knew that there was actually a very small possibility that a person would take up the offer, but people could come in there broken, and just to know that they had somewhere to go was very important.[5]

However despite these activities it was almost always men in the positions of leadership. To continue the story of Wera who organised the meeting for example...:

I was the secretary of our commission. The leader was a man, a doctor, his vice-chairman was a woman. [6]

Certainly as regards to discussions concerning methods of acting and the directions we should take, women had a voice as counsellors and participants in this process and it was a very important voice; although actually the managing staff consisted of men.[7]

In the common room it was half men and half women. I had the impression there was complete equality between the sexes, at the beginning the equality was very clear. But afterwards when it came to activity involving the workers' self-government it was mainly men because that was very dangerous work and a few of them were thrown out of work. ... This work gave them very big possibilities for influencing the politics of the firm, and it was very obvious in which direction that politics was going and in many cases they simply lost

[5] Interviewee no. 2
[6] Interviewee no. 11
[7] Interviewee no. 22

their jobs. They were walking on a tightrope and I think
that simply many women didn't want to take that kind
of a risk.[8]

The general assumption is that women's childcare
responsibilities incapacitate their possibility for activity beyond
the domestic sphere: "If she had small children whom she had
to occupy herself with she couldn't be active".[9]

> One can't disguise the fact that it was far easier for a
> single woman or women in childless families to make a
> decision to give their help. Although I have never seen
> the statistics I suppose that the majority were not
> married women, or somehow were single and not
> burdened with children. [10]

And at first glance these assumptions appear to be confirmed by
the facts; not only do women have to look after children but
they have to take responsibility for the care of all members of
society.

> It was a really difficult situation as a single mother in
> martial law. I couldn't engage in any Underground
> activities because of the risk that my child would be left
> alone. My husband [she was separated from him] gave
> me very little money and I lived with two grandparents.
> They were both very ill and I looked after both of them.
> I resigned from Underground activity.
> [the first woman to be on the Presidium of Solidarity] [11]

> I wasn't really in the Underground. I had an old aunt,
> who had been like a mother to me, to look after and I
> was more important than anyone to her. [12]

[8] Interviewee no. 8
[9] Interviewee no. 17
[10] Interviewee no. 22
[11] Interviewee no. 7

> Two weeks after I got married my mother-in-law fell ill
> with Alzheimer's. So I went to the country to look after
> her and my father -in-law. So I could never be active in
> the Underground. [13]

> That was my only activity after having a baby but before
> that I did everything that was necessary. [14]

And when women chose to be active rather than dedicate
themselves to family duties they still took responsibility for
whatever happened to them.

> My mother had a very serious illness and my father
> wasn't on the best of form. Neither of them still live
> and I think that my activities had an influence on their
> health. [15]

The assumption that women with children were unable to be
active in some ways became a self fulfilling prophesy.

> I personally tried to employ for this work women
> without children. But sometimes they were born. [16]

> We prepared for the strike. Of course those with small
> children weren't expected to stay and only those who
> could would stay and would look after the area and the
> others would stay at home. [17]

However, everything looked completely different when I spoke
to the activists.

[12] Interviewee no. 17

[13] Interviewee no. 1

[14] Interviewee no. 9

[15] Interviewee no. 12

[16] Interviewee no. 8

[17] Interviewee no. 20

But even with children, we did things. I carried
pamphlets, I had a warehouse of reading material at
home. I helped in any way I could. I wrote texts, typed
on the machine or tried to find people who were being
looked for by the police. [18]

However it doesn't mean that there were no women
with children, they were there. And even women who
worked in these housing structures or even those who
gave their own homes, they had regular families with
children and often it was just such women with children
who engaged in this help. [19]

I would also like to point out that six of my twenty one
interviewees were single mothers, as were three of the six
editors of *Tygodnik Mazowsze*. What I think may be going on
(however this is hypothetical rather than conclusive) is that
many women actually make a complete separation between what
was sometimes referred to as 'social activities' and their family
concerns.[20] As Anna explained:

We really didn't think about it. It wasn't that a person
suddenly made a decision to act, it just happened that
you might read something and if you read something
you felt you had to do something and so on. I don't
know anyone who made that kind of decision you just
started doing something little and gradually it became
something more. [21]

The possibility that women separate their 'moral' concerns for
society as a whole (these were the kinds of terms in which
women repeatedly described their activity), from the affective

[18] Interviewee no. 9

[19] Interviewee no. 22

[20] Interviewee no. 12

[21] Interviewee no. 10

and particularistic concerns of their family - and particular
children - seems the best way of accounting for the fact that
single mothers such as Anna risked and lost their jobs and
others risked internment:

> During this time [the period after having a child] I ran a
> newspaper wholesalers, but I didn't get any profit from
> it. My friend took illegal stuff from the printers and
> others came. People came from all over Poland, it was
> one of many wholesalers. It wasn't a very big quantity, a
> thousand pieces of *Tygodnik Mazowsze*, a hundred pieces
> were difficult to carry. No-one took a thousand. It went
> from hand to hand, it depended on trust or we'd all go
> to prison. [22]

The existence of conceptually separate spheres also underlies
Maria's decision.

> Our son was born in '69. He was twelve and he was
> hungry all the time. "Mum I'm hungry, Mum I'm
> hungry", all the time. ... I remember very well we
> divided cheese and Michał, who likes cheese very much
> asked if we could keep some and I said, "No, its for
> others". I will remember till the end of my life that I
> refused cheese for my son, but I think I behaved
> correctly because it wasn't ours it was others'. [23]

However I also find it significant that during the course of the
interviews women would very rarely, unless pushed, mention
their family. In fact I very often assumed that the women didn't
have children - only to find out that I was quite mistaken. It is as
if the two activities were in quite separate 'compartments'. [24]

[22] Interviewee no. 9

[23] Interviewee no. 16

[24] On revisiting this thesis, though, I have come to the conclusion that
there may be little if any separation between women's particularistic
concerns for her family and her moral concerns for society. A woman's

From this perspective, family 'responsibilities' are rarely a decisive or determining factor. Rather they are a kind of natural obstruction which one deals with as best as one can.

> I went with my own small child to public protests and after martial law he was four or five. I went with that little one to various activities, for example help for interned families. Because I had a small child there were many things I couldn't do. But I did those things I could, and if I came home at midnight I would cook supper, wash clothes and prepare things then. My husband always ironed. I just managed somehow at home. If I don't wash the windows once a month but three times a year its still okay. I don't have to wash them once a month. Everything doesn't have to shine. ... If people have other activities it mobilises them and it is possible to fit everything in without greater suffering to the family. The family just has to put up with it. [25]

> I had a totally dependent mother but people helped me by taking care of her. Splendid people [who took the attitude] "We can't do anything else but at least we will help you do what you are doing by taking care of your mother." In fact they never but never let me down. She was never left without what she needed. They never let me down. [26]

> The police often used the threat that they would put the women into jail, and the children would be put into an orphanage. Women who had already been engaged in opposition activity knew it was improbable. But they protected themselves as well. In a family there was

wider concerns emerge out of (or are an extension of) her acute awareness of the needs of the individual at the private level.

[25] Interviewee no. 18

[26] Interviewee no. 14

always someone who they knew could be a care-giver for the children if necessary. [27]

I was often in fact told stories of how women's older children would actually support or become involved in women's activities. One woman described how her son and his friends at school established a network whereby they would all go and check what there was in the nearby shops, exchange this information with each other and then the boys would report back home to their mothers.[28] Other women told stories of how their children would cook for them, help in leaflet distribution or be involved in other ways. In fact what was often of more concern to the women than the adverse effects on their family were the consequences for their professional life:

> My professional life did suffer. For example I defended my PhD very late. I also cancelled various possibilities for studying abroad. I preferred to work here in Poland where I felt there was a need. [29]

> At this time nothing could happen in one's professional life. People didn't write PhDs and habilitations because they didn't have time for that. It was a period when people on the other side went to the front. Generally we were demoted professionally. The positions which we had, we lost. Some of us were thrown out of our jobs. Many people did something completely different. [30]

However despite women's assumption of very significant responsibilities, "they didn't have the role which hypothetically they could have had".[31] It transpired that there were other factors holding them back

[27] Interviewee no. 22

[28] Interviewee no. 19

[29] Interviewee no. 8

[30] Interviewee no. 15

[31] Interviewee no. 21

Many women who were active had problems with their husbands who thought that they weren't looking after the family. That is if the husband wasn't in the Underground. [32]

Before my daughter went to nursery school we split the childcare, we didn't use family help. When my daughter started attending nursery school I started working for Solidarity. My activities in Solidarity affected my marriage. Half a year later he found himself another woman. [33]

When a woman has a husband he is more active, that is natural and she is as it were his right hand. Those who were single or unmarried took that very active role. [34]

Women in the Underground were either single or married to someone who also worked for the opposition. There were men who got involved in the Underground against their wife's will, but I have never met a women who got involved in such activities in spite of her spouse's disapproval. (Penn, 1993: p.6)

The reason why women whose husbands were in the opposition were more likely to be able to participate was not because men in the opposition were of a more magnanimous bent, although in some cases they might well have been. The reason why women whose husbands were in the opposition could participate was rather because their husbands, "as always in the history of Poland", were away.[35] Thus, what appears to have happened is that not only was there an absence of public

[32] Interviewee no. 15
[33] Interviewee no. 7
[34] Interviewee no. 13
[35] Interviewee no. 16

patriarchal structures, there was also an absence of the private
patriarchy in the home.

Before going on to consider the significance of all these
activities for the processes of transition as a whole, I would like
to make one more point; while it was the private sphere which
provided the foundation for all these activities, it was also the
private sphere which paid the price:

> Solidarity broke many marriages. Men would leave
> home for a few years as activists and there were various
> arrangements between men and women. ... Of this we
> talk little, but from my observations there seems to have
> been quite a lot of that. ... Rather men left the home,
> women held the family together and when men left the
> home the marriages fell apart. There were lots of
> divorces, concubinages, children from various kinds of
> relationships. A mess of families. I think it's a loss from
> this point of view. It was very unpopular what
> happened as a consequence of Solidarity. I know about
> this because of my job [psychiatrist], people come to me
> with their various problems. [36]

However, my one male informant, Bujak, saw things in a
different light:

> There is one sphere of a life of conspiracy which is not
> described and never will be. This is the sphere of all
> these relationships between men and women ... great
> tragedies, divorces ... great new affections - really great
> and marriages often happy and these meetings which
> finish in weddings. For instance, one of the most
> beautiful stories... [37]

[36] Interviewee no. 13
[37] Interviewee no. 22

So in order to understand the significance of women's activities it is necessary to locate the Underground in the context of society as a whole. This wider perspective will not only shed light on the role of women but also help us to understand in greater depth their exclusion from the public political sphere.

Ch.4
TRANSITION TO DEMOCRACY

This chapter examines the crucial role which the Underground played in facilitating the transition to democracy. The point of view taken is that the Underground counteracted the state's efforts at coercion through the creation of a clandestine public sphere. It will then go on to examine why women, who played such a significant role in the Underground, were comparatively absent at the negotiating table and have been under-represented at the 'higher' political level ever since. The reasons for this will be located in the mechanisms of Underground society and the way in which the transition took place. This argument will then be developed in the following chapter, which complements it by exploring the absence of women in public life as a result of their role in Polish society as it has developed historically.

Imposition of martial law was followed by an intensification of external coercion based on direct physical violence, using such penal sanctions as corporal punishment, imprisonment and even death. The aims of this external coercion were firstly to isolate, mainly through internment, several thousand Solidarity leaders and then to subject tens of thousands of activists to strict supervision, thereby causing the disintegration of the movement.

This objective was further served by the threat or actual use of physical coercion in order to paralyse communications. It was achieved by disconnecting telephones, banning any permanent move to another town, imposing curfews, carrying out personal searches in the streets and at home and closing virtually all the editorial offices of daily newspapers, magazines and publishing houses (Koralewicz, 1987: p.15).

In addition a special 'studybureau' was set up in the Ministry of Internal Affairs for the purpose of weakening Solidarity. The bureau concentrated on the spread of misinformation, using mechanisms of psychological intimidation, character assassination, the dissemination of alarmist rumours and the editing of tape recordings of comments made by Solidarity spokespersons in order to change their meaning (ibid: p.16).

Physical coercion was also used to help end the resistance of those work forces who were protesting against the outlawing of Solidarity, the internment of its leaders and the suspension of all independent social organisations representing the interests of various social groups. The threat of recourse to physical coercion also meant that when food prices were drastically raised in the second month of martial law, people did not respond with social protests as they had done in 1970, 1976 and 1980.

The realities of physical coercion, in the shape of internment, interrogation, searches and trials appeared to eliminate all expressions of support for the ideas of Solidarity. This was reinforced through economic coercion which involved the dismissal from employment of Solidarity activists, or the imposition of compulsory work through, for example, the militarisation of certain enterprises and institutions. The price rises themselves, which pauperised the overwhelming majority of society, also constituted a form of economic pressure.

Another mechanism by which the regime tried to re-appropriate the public sphere was through the elimination of genuine public opinion. Prior to 1980 all the media including public opinion research institutes were controlled by the authorities, and public opinion itself could be defined and shaped by them. After the creation of Solidarity this was no longer the case, and the authorities were forced to deal with public opinion as an autonomous variable. However, after the imposition of martial law virtually all academic survey research, like most other academic activities, was terminated or suspended. Public

opinion research also became much more circumscribed, and the results were much less frequently made public (Mason, 1985: p.207).

Through these mechanisms the authorities appear to have been trying to induce passivity in the population, break up the institutions of Solidarity as well as stop the further transmission of their ideas, and generally create a situation in which people would once again be dependent on and submissive to the authorities. In many ways they seemed to have succeeded in their aims. When in 1983 survey research did start to re-appear, it revealed a great public malaise in the aftermath of martial law. Nowacki suggested that there was a new generation which was "suspicious of all public institutions and important persons".[1] This was a consequence of widespread disillusionment with the official ideology and institutions among a large and crucial sector of Polish society. Other surveys, even official ones, reported widespread alienation, apathy and hopelessness. Mason reports that:-

> A large majority of those polled believed that 'openness in stating one's opinion, willingness to make sacrifices for the public good, and generosity' had become rare in Polish society. In the face of all these problems people felt passive or helpless. (Ibid: p.229)

He goes on to conclude:

> Indeed, after the flood of participation and hope in 1981, Poland now was overcome by anomie. Anomie has been defined by MacIver (1950: p.84) as, 'the state of mind of one who has been pulled up by his moral roots... The anomic man has become spiritually sterile, responsive only to himself, responsible to no one. He lives on the thin line of sensation between no future and no past.' All this aptly applied to Poland in 1983. Poles

[1] Nowacki (1983) quoted in Mason, 1985: p.228

had been pulled up by their roots with the crushing of
Solidarity. The regime had destroyed Solidarity, but had
also discredited itself... Poland, once again, had been cut
off from its past, and faced a future without promise.
(Ibid: p.231)

This was the public face of Poland. But in the Underground
there was a different picture. However because of its location in
the private sphere, and the difficulties involved in researching
something which is clandestine, it tended to be a neglected part
of the transformation equation - as reflected in Melanie Tatur's
summing up of early transformation paradigm:

Subsequent change was then understood as "systematic
change in terms of an imitating revolution according to
the 'model' of western democratic capitalism and
introduced 'from above' by means of 'neo-liberal'
economic policy and legal innovations." Society was
treated as the object of reform policies introduced by
the government... (Tatur, 1994: p.93)

This is a reflection of the top-down focus of the literature,
which has tended to give primacy to the actions and decisions of
political leaders. Consequently the Underground is ignored, and
with it the work of women, and too much is attributed to the
legal Solidarity period and to its representatives in the leadership
afterwards. This results in the view, of which the prime
exponent is Jadwiga Staniszkis, of Solidarity as a revolution
implemented from above (Staniszkis, 1992). However I would
prefer here to emphasise the importance of the Underground,
and show how drawing attention to this level helps us to have a
more complete picture of the processes of transition which
came later.

Jadwiga Koralewicz explains that:

The decision to withdraw from the system has not been
an easy one to take. Apart from private enterprise and

> the church all other institutions are controlled by the
> state and party power apparatus. People today must live
> within a system of institutions. Opting out of one
> institution entails acting within another. (Koralewicz,
> 1987: p.10)

I would like to argue that the Underground provided the
alternative institution which enabled people to reduce the power
of the state in their everyday lives. Thus people who lost their
jobs through their real or suspected involvement in opposition
activities had, through the second economy and support
networks for meeting subsistence needs, an alternative network
of dependency which enabled them to remain outside the state
realm.

This meant too that others also could persist in their opposition
activities, knowing that there was a safety net there if they were
ever caught. And although the authorities hoped they could
isolate the activists from the rest of society through internment,
the Underground meant that such actions had completely the
opposite effect. Those who were interned became a point of
focus around which society rallied, and a source of wide-
reaching networks of support. Their plight drew the attention of
the West, which consequently gave additional resources to
support the second economy. At the local level women with
imprisoned husbands would talk about the enormous moral and
material support which they received from neighbours.[2]

It was these alternative networks which enabled people to opt
out of participation in the official public sphere, in the way Ost
explains:

> In the first years after martial law, the opposition
> boycotted the new trade unions, the new self
> management councils, the new professional associations

[2] Interviewees nos. 19 & 13

- in short, every institution that was created to replace a
similar institution from 1980 – 81. (Ost, 1990: p.174)

The way in which the Underground enabled them to do this is
illustrated by the many cases of actors and other artists for
whom the Underground collected money, found alternative
venues and, for opposition writers, provided a market for
books. Likewise musicians and composers were able,
realistically, to present a code of conduct in spring 1982 with the
following proposals:

> We must also immediately start to create an unofficial
> circulation of music. It is possible and realistic, and it is
> also realistic and possible [sic] to create a financial basis
> for this activity... Our professional activity does not
> have to be organised in the offices of the rulers. (Ramet,
> 1995: p.91)

Such activities enabled artists to boycott officially sponsored
shows, stop appearing on television and radio and altogether
starve the state-created public sphere of culture.

> In this way, the cultural intelligentsia withdrew from the
> system and set the stage for the development of a lively
> Underground culture paralleling the Underground
> political scene. (ibid)

Also very important was the way in which participation in the
Underground gave shape and meaning to people's lives. Thus
interviewees mentioned the depression which they were thrown
into when martial law was imposed, and how it was overcome
when they became involved in resistance activity.[3] Through such
activity people could express their beliefs in action, and live
according to their own cultural norms; factors essential for
overcoming the debilitating effects of 'Anomie'. In this way the
Underground provided that social realm in which people's

[3] Interviewees nos. 2 & 3

attitudes and behaviour could match the goals and values which had been established in the Solidarity period, but which had no expression in the official public realm. Thus, whereas David Mason (1985: p.237) comments that "the chain of cultural transmission is broken", because the regime could no longer inculcate official values in young people, I would argue that it was *not* broken but passed into the unofficial sphere.

Jadwiga Koralewicz discusses 'cognitive dissonance', and explains how people's capacity for action could be reduced when the information which they receive about their reality clashes with their own experience of it (Koralewicz, 1987: p.8) The Underground press understood this, and by providing nation-wide information was able to counteract the mis-information of the official press.

It also conducted its own research to collect reliable information. For example one of my interviewees explained how she and her colleagues had hidden in various doorways in order to collect the true statistics of the number of people who voted in the Sejm elections in 1985.[4] Such procedures, by reflecting people's experience of reality, reinforced their value system and increased their motivation to act.

The Underground was not only important in eroding the official structures, but also had a vital role in preparing people for democratic participation. Frentzel-Zagórska (1990) explains that these societies "have to form the psychological and cultural foundation for the type of civil society that is able function in democratic states and market economies". Because Poland did for such a long time maintain the values and cultural attitudes necessary for democracy in the Underground sphere, its 'psychological and cultural foundations' were far better prepared when the time came. Furthermore, because Underground conditions made it impossible for Solidarity to exist as a vast 'mono organisation' as it had done in its legal days, and because

[4] Interviewee no. 4

its Underground leader, Zbigniew Bujak, actively pursued a fragmented approach, there was the development of a great diversity in strategy and political opinion. As Wiktor Kulerski said in 1986:

> Political groups are necessary as well as organisations such as Freedom and Peace [bodies representing] ethnic minorities, and youth associations. Such variety is normal in a democratic society for a future independent Poland, then we must start to lay the foundations now - in the form of an underground society. (Ramet, 1995: p.98)

In the period immediately following the political breakthrough this 'variety' resulted in too many political divisions. But in the longer run the development of many differences of opinion and the institutional expression of them bodes well for the development of democracy. Finally the maintenance of a network of clandestine union cells provided at the shop floor level a basis from which a future system of factory management could and in some cases did develop. From this perspective civil society was reconstituted prior to the transition rather than, as is commonly held, as a result of it.

Some kind of continuity was maintained with the pre-martial law period at the organisational level through the formation of the Interim Co-ordinating Commission (TKK) on 22 April 1982, which kept going until it was dissolved and replaced by the National Executive Council in October 1987. This gave to the naturally evolving Underground some kind of conscious strategy, as summed up by Warsaw Solidarity activist Wiktor Kulerski in 1982:

> This movement should create a situation in which the authorities will control empty stores but not the market; the employment of workers but not their livelihood; the official media, but not the circulation of information; printing plants but not the publishing movement; the

mail and telephones; but not communications; and the school system but not the education. (Ramet, 1995: p.65)

More important even than providing a strategic form to the naturally evolving activities was giving the Underground an institutional form with which to confront the authorities, and which the authorities could negotiate with when the time came. The existence of an alternative structure, however questionable its representativeness may have been, meant that one authoritarian regime was not replaced by another - which is what could have happened had a non-official option not been available.

The alternative public sphere becomes the public sphere

Gradually opposition tactics started to pay off. Although the regime did not let up on the opposition, the existence of an alternative public sphere meant that the government had to mix an increasing dose of liberalism into its political recipe, in order not to completely alienate itself from society. Some kind of social conciliation was particularly necessary to carry out the economic reform needed to help the ailing economy, and in order to receive assistance from the West (Ost, 1990: p15).

Following the imposition of martial law, cultural policy had in fact been much more open than in other parts of Eastern Europe. However, the earliest sign of a real change in approach appeared in 1983, with the printing of a provocative article by Jerzy Turowicz on the front page of *Tygodnik Powszechny*. In it he criticised the new legislation which was supposed to be replacing that of martial law (ibid: p.155). This article appeared together with a formal reply from the government press spokesman, Jerzy Urban, and also Turowicz's 'unrepentant response' (ibid: p.157). But things still moved very slowly until the amnesty of political prisoners in 1986, which initiated a new period of political and economic reform. The government's new

policy was most clearly reflected in print and by 1986 censorship seemed to almost disappear, as Ost explains:

> No longer was the Underground press needed to talk about poor conditions on the job, about schools and hospitals falling apart, about the destruction of the environment. Official newspapers brutally dissected the ills of the system on their own ... Authors and subjects systematically banned in the 1970s were the topics of symposia and extensive public discussions ten years later ... Interviews with key opposition activists appeared in major weeklies ... Meanwhile harassment of Underground publications was curtailed considerably. (ibid: p.176)

One of the most dramatic examples of the new policy was the decision by the authorities to legalise the Underground journal *Res Publica.* This was a top quality theoretical journal on politics and power which was profoundly anti-communist, and in the 1970s people could be jailed simply for possessing it. Marcin Król, its editor, remarked on the significance of the event by describing Poland as "a changed country, a different country" (ibid: p.177). And those who remained sceptical, thinking that the new freedoms would only last as long as the opposition remained quiet, were proved wrong in 1988 when the new calls for the re-legalization of Solidarity were printed in full.

As Kuron explained, a consequence of Solidarity and the Underground period which came afterwards was that the communist party could no longer control the public sphere and suppress independent social ties. During this period the Underground press had become so free and pluralist that the authorities could either "carry on with the pointless propaganda or agree to real information in the mass media. They chose the latter." Consequently, "The official vision of the world has practically ceased to exist, and with it has gone the Party's monopoly of public life" (ibid: p.179).

This change in relation to the press was not the only expression of the government's new approach. A few weeks after the general amnesty in 1986, a broad based Social Consultative Council was proposed - as an open forum where members could speak out publicly on all important issues of the day. This was created in December 1986, and was made up of 54 mainly non-party activists. It held a series of genuinely open and provocative discussions, which were published in full and which in interest value became competition even for the Underground press. In this way they helped to extend the limits of acceptable political discourse.

Also in the autumn of 1986 the government announced the creation of a cabinet-level post of Officer of Civil Rights. This post was taken by Ewa Łętowska, from the Polish Academy of Sciences; a non-party member who soon proved that she was not going to be simply an administrative arm of the government. Then in the Autumn of 1988 there followed a new law on associations, whereby a new historic bill was drafted which granted virtually complete freedom of civic association.

Finally, while in the first years of martial law the government had set up new trade unions, new self-management councils, new professional associations, all to be boycotted by Solidarity, by 1986 it had become apparent that these organisations were not simply replicas of what had existed before 1980. In the first years after martial law the government did not make up fake membership figures, or pretend unions existed where they did not. By the middle and later 1980s there were even clear signs that the unions were prepared to oppose government. In fact by the end of the decade workers were joining official unions in preference to Solidarity, which was pushing ahead with controversial economic reforms.

The most astute observations on these changes were made by Jacek Kuron. He explained how "The belief that various interests must have their institutional expression, their representation, became prevalent". In fact they became so prevalent that

"The authorities accepted this principle", although the system is actually based on the idea that the party represents all interests and therefore there can be no others which need expressing.

He goes on to explain that when the government first began "appointing various consultative bodies, new unions, councils and committees, it all looked like a puppet theatre". But because of the experience of Solidarity, and the existence of independent competition, "these new organisations could not remain in the realm of fiction - the official institutions became to a degree genuine" (Ost, 1990: p.180). The new groups such as the ecological clubs and Consumers Federation were not just covers for the party but "really attempts to defend consumers' interests and protect the environment." According to Kuron, even the official unions bear "a closer resemblance to Solidarity than to the old unions" (ibid).

Where did all the Underground activists go?

As explained in earlier chapters, women were central in running the Underground, and in maintaining some form of resistance which prevented the legitimisation of the official sphere. The Underground did provide many women with a spring-board to greater public involvement, enabling them to gain experience and show their initiative in ways which they would otherwise have been prevented from doing. However, when it came to the higher-level political involvement, women were nowhere to be seen.

At the Citizens Committee, there were very few women involved in discussions: at the Magdalenka, none; and at the round table, one. Women are still invisible at the political level today. In order to understand this exclusion of women it is necessary first to examine the way in which the leadership became separated from the Underground as such. I will then examine the sociological circumstances which prevented women from *taking* the leadership role in the next chapter.

The imposition of martial law and the internment of leaders which accompanied it meant they were isolated from the beginning. Even those who for most of the time escaped internment had little contact with each other, as a former Solidarity leader recalls:

> My first task was to get in touch with the activists in my region. It was extremely difficult. I had to do it by myself. I travelled by train and then looked for the people I needed to see. I often found people in very mundane places or even by chance. One man whom I needed to see for example, I found in a cafeteria. [5]

And they had even less contact with the 'rank and file', as one interviewee recounted:

> The contact was through the newsletters. Bujak had twelve disguises. He was in contact with ten people and no one else apart from that group, which rarely met together. [6]

Consequently that part of the mass movement which had transformed itself into the Underground made do without the previous leadership as best it could:

> When the leaders were in prison, there were others who went into the high positions. It was a huge organisation, and other people like myself began to organise the underground. Those who managed to hide made a second structure. It wasn't the same people, but there were a lot of them. We made a whole structure. [7]

In the meantime the workers were becoming increasingly alienated from the leaders:

[5] Quoted in Ramet, 1995: p.676.

[6] Interviewee no. 21

[7] Interviewee no. 15

> He [Wałęsa] stopped being 'theirs', and started to be a politician. He already had a Nobel prize, he had a bodyguard, he had already met Margaret Thatcher. He had a telephone so that Kiszczak could telephone him. He had the trust of the other leaders and people knew him, but he stopped being the ordinary man's leader. This stopped with the Nobel peace prize; he wasn't ours.[8]

Of others, she commented:

> In the Underground there were a few workers, but its not them we talk about. Exceptions like Frasyniuk and Bujak were rather rare. However they were more identified later as a section of the Underground political elite. One didn't think of Bujak as a worker from Ursus; one thought of him as a leader of the union. I think that gave the impression of distance from the workers ... There was an image of Solidarity abroad, and maybe at home, that the Underground was made up of professional politicians.[9]

Furthermore there was an increasing lack of democratic mechanisms which could enable the leadership to be representative of the rank and file:

> During the legal period until martial law it [democracy] was growing, with many growing pains, but it *was* growing and clandestinity destroyed it. There were some efforts, but it couldn't be otherwise; you can't have a totally democratic clandestine movement, that's not feasible. It wasn't very clandestine, therefore it was somehow democratic ... But still, if a congress was not possible, if a change of leadership was not possible, then

[8] Interviewee no. 21
[9] ditto

immediately you have something like an apostolic
kollegium and charisma, which has to be passed on from
one leader to another or kept. So Wałęsa was a leader
for much longer than was to be expected, and also
without the normal democratic challenge.

We had no free press because clandestine press is not
free; it is clandestine press. It has no censorship, but it is
read by the police [therefore] if you write in this press
you must realise that it is not only read by your friends
but very thoroughly studied by your enemies. Do you
publish in clandestine press an article about how Wałęsa
is deteriorating? You don't. You can think it, or say it
here and there; but you won't publish such a thing
because it's against the interest of the opposition. You
will not denigrate your leader, but these leaders need a
free press to criticise them and they were not getting it.
[10]

Wiszniewski too explains how "a complete block on democratic
mechanisms" is the dark side of covert operations. The aspect
which he elaborates is the way in which things were not decided
in a democratic process, but through trust in friends and closest
friends of friends. The Warsaw opposition elites were able to
assert increasing influence through their acquaintances - dating
back to the times of KOR - the proximity of Western embassies
and foreign correspondents and, last but not least, the easy
access which they had to money and equipment sent to the
Polish opposition by friends in the West. They also had the
advantage of knowing how to manipulate the bureaucratic
system to their advantage and how to arrange things; if not
through a cousin in the Communist Party's Central Committee
then through a related priest in the Episcopate. (Wiszniewski,
1989/90: p.61-66).

[10] Interviewee no. 14

It was not long before this division between those who had
maintained the Underground and the previous leaders started to
have public political expression. This began in September 1986
after the government had declared a general amnesty. When the
newly released political prisoners emerged they 'bumped into'
those members of the Underground who had replaced them,
and it became apparent that there were too many people, with
too many conflicting ideas and not enough space at the top.
Wałęsa with his hand-picked advisors and colleagues chose a
dual strategy; they maintained the Underground TKK and
created the Provisional Council (TRS) whose task was to
prepare for Solidarity's return to legality by acting completely
above ground.

The plan was that the TKK leaders would surface, while the
practical network created by the TKK would stay intact and be
co-ordinated by a group of activists who would operate with
strict anonymity. This step provoked controversy, with some
complaining about the possibility of a dualism in leadership and
saying that this would cause the leadership to lose touch with
grass roots (Ramet, 1995: p.94). Wiszniewski also explains how:

> The 'professionals' did not risk much by coming into
> the open, on the contrary, they gained publicity, while
> the rank-and-file membership and organisers of
> clandestine factory committees were taking a
> considerable risk of being sacked and having their
> organisations completely paralysed. (*op. cit.*: p.62)

Then as it became apparent that there were unlikely to be mass
arrests, the Underground safeguard was no longer felt to be
needed and in October 1987 these two bodies were disbanded
and replaced by the National Executive Committee. Dissolving
the Underground in this way enabled 'Solidarity' to talk with a
single voice, and increased Wałęsa's possibilities for negotiating
with the government.

Not only was the leadership separated from the Underground which had sustained it, but it also appeared to disown its trade union, working-class base. This was partly because systematic political reform appeared to be the way to proceed when searching for a goal, rather than shop floor politics. When a few factory cells did register new Solidarity Unions these were ignored by the leadership for nearly a year after they had begun (Ost, 1990: p.164). Furthermore, there was a new emphasis on economic reform, which was not compatible with workers' interests. This was accompanied by a right wing critique of Solidarity, which attacked its apparently left-wing tendencies and mass movement character. By September 1987 it had become so removed from the concerns of everyday people that 22 members of the 1981 National Commission wrote to Wałęsa and complained of the "virtual lack of concern with social and standard-of-living problems" in the "statements and action of the official solidarity leadership" (ibid: p.169).

Things came to a head with the strike waves of May and September 1988. It was these strikes, headed by workers demanding the resurrection of the trade union Solidarity, which brought the government to negotiations. But the negotiations then proceeded with the 'Solidarity' leadership before any trade unions were established. This may however have been partly on account of the conditions set by the communists. Wiszniewski points out though that an equally strong factor, if not actually stronger, was the attitude of the opposition elite. They feared that pressure from below could tie their hands at the talks, and this was partly on account of the conflicting attitudes which unionists and leaders may have had towards economic reform.

This lack of democratic mechanisms was reinforced by the subsequent practice of appointing members of decision-making bodies instead of electing them. As a result of this the subsequent union structures have been built from the top, unlike in 1980 and 1981 (Wiszniewski, 1989/90: p.62).

In this way the Solidarity leadership became separated from the workers and the Underground. Two of my interviewees were, to their surprise, among those nominated to high positions within the new Solidarity structure. However the representation of women in leadership positions represented in no way a reflection of their contribution to the Underground.[11]

In earlier chapters I have considered the role of private patriarchal structures keeping women out of leadership positions. I will now go on to examine and analyse some other factors and mechanisms that appear to have been involved.

[11] Interviewees nos. 7 & 13

Ch.5
POLISH WOMEN AND POLITICS

As established in chapter two, women were central to the maintenance of Solidarity and an independent society, during the legal period of Solidarity but even more crucially during the Underground years. And for some women these activities in the movement acted as a springboard for an influential role in society after the transition:

> When the Citizens Committee started I went to work in it. I helped before the elections. At the beginning it was just my husband then it broadened out to include everyone. Afterwards the Committee continued to exist and it was suggested that I start in the list of those to be elected to self government. Because I was active I was chosen. We started to build the first integrated school in Poland with handicapped and able-bodied children where they could learn about other cultures. And we organised various actions for raising money. Then it was suggested that I work here [organisation promoting local democracy] ... All the time my political work continued. ... I have recently started working for the Ford Foundation. [1]

> The union taught me a great deal. Previously I hadn't dealt with all the problems of making programmes for the health service which I only did through the union. They then offered me a job as the Vice-Minister of Health and that was a consequence of what I did for Solidarity. So it had a huge influence on me. [2]

[1] Interviewee no. 13
[2] Interviewee no. 15

I worked in the Warsaw University union and also in the Mazowsze regional union. Later in the elections four years ago I was delegated a member of the Praesidium of the Country Commission responsible for politics and social affairs. In the Country Commission there were six women; of the fifteen people in the Praesidium I am the only woman. [3]

Starting as laymen, gradually they became professionals in social, political, or journalistic work. For example, a friend of mine, Helena Łuczywo, got her degree in economics and English philology. Her first contact with journalism was typing the first Underground newspaper in ten copies. Today, an excellent editor and journalist, she runs a daily with a circulation of about half a million, and her managerial skills, which she acquired in the Underground, can now be seen in full light. The firm that she manages employs a few hundred people, has branches in many Polish cities, and it's still expanding. (Sczeszna, 1990: p.2)

While not all of my informants were as high-powered as those represented here, women's Underground activities did often lead onto bigger and better things. One journalist, on losing her job in 1981 because of her oppositional activities told her editor that she would return to the newspaper in her place, which in 1989 she did.[4] Seven others were also journalists or working for Polish television, three were highly active in local level organisations and others were very active in Solidarity. Fuchs Epstein, writing in 1970, described [Polish] women as being "like the sediment of a good wine, they have sunk to the bottom" (Titkow, 1992: p.30). The Underground however, with its absence of established patriarchal institutions, enabled women, like cream in milk, to rise to the top. But while from the

[3] Interviewee no. 15
[4] Interviewee no. 9

broader perspective the Underground provided a temporary open door through which many women passed, once normality was resumed the doors were again firmly shut, and traditional gender divisions reinstated in an even more accentuated form.

From the outset of Solidarity, there was an absence of women in leadership positions, for although they are estimated to have constituted around 50 percent of the rank and file, as one went up in the Solidarity hierarchy the number diminished. The Interfactory Strike Committee included only two women, but sixteen men. The elections in spring 1981 resulted in a total of only 7 percent female delegates being sent to the first National Solidarity Congress, and an even smaller percentage of women entering the National Commissions. Only 7.8 percent (sixty nine) of the 881 delegates to the Solidarity Congress were women, and there was only one women in the National Executive Council elected in the fall of 1981 (Jancar, 1985: p.196). The nineteen members of the Conciliatory Commission included only one women; there was a single woman among the National Commission's 82 members, and of the 21 members of the auditing Commission there were just three women (Einhorn, 1993: p.159).

Despite women's activity in the Underground this pattern was echoed in the changes taking place at the end of the 1980s. In the 1989 roundtable talks neither the opposition nor the government had any women representing its side's interests. The only woman, who was on the government side, renounced any particular association with women's problems. The extent of women's participation was as experts accompanying the negotiations, and even here only the health subgroup could claim to have a reasonable representation of women (38.9 percent). For the other groups participation rates ranged between none and 8.7 percent (Regulska, 1992: p.186).

Then in the appointment of candidates to the Sejm and Senate, before the partially free elections in June 1989, women constituted a decided minority. Among the 2,500 candidates

only some 200 were women. The Citizens Committee had 16 women candidates for the Sejm and 6 women candidates for the Senate. Among the 460 candidates elected to the Sejm there were 62 women, and among the 100 persons elected to the Senate there were 6 women (Siemieńska, 1994: p.616). As Regulska explains:

> Women had been very visible in the opposition, in part because of the informal structure of those organisations. But their involvement during the opposition years did not translate into an invitation to the negotiating table; none of the groups that negotiated with the regime was chaired by a woman. (Regulska, 1992: p.40)

In order to understand how this came about it is necessary to examine the maintenance of traditional roles despite the alleged agenda of the socialist state, and to see that these roles had deep roots in Polish history. The continued importance of the private sphere in Polish society, the enhanced role of women within it, and the absence of means of fulfillment to be derived from the public sphere were all reasons why men, rather than women, were the first to enter the public sphere.

As shown earlier, in chapter one, the Polish state had disappeared altogether with the partitions – during which the country was divided and integrated into three separate infrastructures. Preservation of the nation came to devolve on to the private sphere, and since men were away fighting, dying, in prison or deprived of the means of eking out an existence, women came to play a tremendously important role in this. At the private, clandestine level they were pivotal in creating and sustaining a national consciousness (Brown, 1996b). Their vital role was given formal recognition with independence in 1918, when women were granted equal citizenship rights with men.

Although a period of independence followed, it was very brief, and followed by the total destruction of the Second World War, so it seems unlikely that the social patterns established in this

period had a chance to take hold. Rather it was the clandestine patterns, linked to the private sphere, which were reactivated with the Second World War and maintained throughout the communist regime.

However the communist system appeared to take many steps to transform traditional gender structures. According to Dr Morecka, while ...

> ... equality of rights in all spheres for both men and women was formally proclaimed in Poland by the Constitution of 1919 ... it was only in 1945 ... that the principle began to be truly applied, especially in economic life. It is gradually being extended and developed and it is constantly stressed in basic legal and political documents, such as the Constitution of People's Poland, the Labour Code and the Family and Guardianship Code, as well as the numerous resolutions adopted by the highest organs of the state, the Diet and Polish United Workers' Party. (Morecka, 1980: p.43)

And on the face of things there appeared to be evidence to back this up. In the early 1950s job opportunities were created for both men and women, and the growth rate in the number of employed women outstripped that of men (Siemieńska, 1994: p.612). During the years 1960-74 there was a 31 percent increase in the female labour force. This was accompanied by important structural changes, with the number of women active outside agriculture dramatically increasing and those active within it falling. Outside the agricultural sector the rate of participation of women in economic activity increased by 44 percent, and within certain age groups by as much as 60 percent.

As a result women accounted for 46 percent of total employment (Morecka, 1980: p.45). This increase was facilitated by the amenities and services provided for working women, including the care and education of children, as well as by providing educational opportunities for women. Thus between

1960 and 1974 the number of economically active women with higher education increased by 155 percent and the number of those with vocational certificates increased by 773 percent (ibid).

However there were many caveats, which meant that any challenges to the traditional structure remained purely in the realm of appearances. These included the highly gendered division of labour, the fact that women's wages were on average one third less than men's, and that women were consistently employed in less prestigious jobs despite the fact that their educational levels were higher than men's (Siemieńska, 1994: p.613). However the maintenance of traditional structures lay deeper.

While the equal opportunities of the Stalinist period were summed up by the woman on the tractor image, men featured far more prominently in the press. Where men and women were shown together the men would usually be in an instructing and commanding role and women in the role of helpers. Articles about agriculture and industry (which, along with praise for the party seemed to comprise the sole content of the papers) spoke only about men, even in those areas such as textiles and piece-work where women were undoubtedly dominant.

At the symbolic level the emphasis on heavy industry rather than on consumer goods was male- rather than female-oriented, and accentuated the extent to which women's equality was premised on being like a man. While Stalinism was short-lived, the patterns set the pace for the rest of the period.[5]

Furthermore, while the Family Code of 1950 enshrined the equality of spouses within the family, effective equality was understood in terms of economic participation, meaning employment, which was a pragmatic equality subordinate to the goals of the state. Thus during the 1950 - 1956 six year plan,

[5] This conclusion was arrived at after the in-depth study of 20 copies of *Trybuna Ludu* from the Stalinist period.

when Poland was attempting to recover from the devastation of the war, there was a mass mobilisation of women into the labour force. But when there was a labour excess or the birth rate was seen to be declining, as during the 1970s, women were encouraged in their maternal role (Sokołowska, 1981).

The limitations of the communist understanding of equality were reflected in their policies and propaganda. Underlying the policies aimed at relieving the burden of childcare and housework was the assumption that these things were specifically the woman's burden. Consequently paid sick leave, maternity and childcare leave, fell exclusively to the woman, leading them rather than their husbands to take time off work. This militated against women being considered suitable candidates for management positions since they were too often absent from their jobs (Einhorn, 1993: p.47).

Propaganda, likewise, did not challenge traditional gender divisions. 'Family Policy' was a much propagated slogan during the late 1970s but it was seen primarily as part of the 'woman's question'. Childcare services, social welfare benefits, care for the aged and handicapped, services facilitating housework and household management were all assumed to form a woman's sphere. The mass media often used the slogan, "Let us help the working woman", taking it for granted that the double role of family and work is purely a woman's affliction.

At the same time there was no attempt to elaborate a role for men in the domestic sphere, and they became marked by their absence. The Polish mass media frequently projected the model of an incomplete family, that is one deprived of a father, and the press often published pictures of women as mothers but not men as fathers. When reading about a woman's professional achievements one would learn that they had children; with men one would learn only about their professional achievements (Sokołowska, 1981). This gave rise to the situation where a woman's sometimes quadruple burden was contrasted to men's single role. This picture increased the political force of the

state's attempts to improve the position of women, while at the same time they were reinforcing and reasserting the traditional role.

The importance of women's traditional role was enhanced by the increased functions of the private sphere under a communist system. At a practical level women in the private sphere were left to compensate for the absence of consumer goods in an economy which preferred heavy industry. This left women in the shop queues for hours, increased the work load at a time when household gadgets were taking over in the West, and turned housekeeping into a skill of the highest order. According to Anna Titkow, these difficult living conditions, combined with women's economic importance, led to a specific 'managerial form of matriarchate'. This matriarchy...

> ... includes carrying heavy net bags full of shopping, suffering from lack of sleep, terribly tired but, at the same time, having the justifiable sense of being an indispensable family life manager, performing duties and tasks that would be burden enough for several persons. ... the matriarchy is a strong source of the positive reinforcement of self-esteem and of the feeling of power for Polish women. Until now, they take strength from the awareness that 'without us and our sacrifice nothing would work at all'. (Titkow, 1994: p.318)

It also fell to the family, and specifically to women, to compensate for the inadequacies of state provision by being the providers of welfare. Anna Giza-Polesczuk shows how, although the state was supposed to provide cheap kindergartens, pensions, social security, and health care in practice it was the family who ended up meeting many of these welfare needs. Thus mothers relied on their mothers to help with child care, parents went on living with their own parents, and grandparents participated in household activities, thereby receiving a much needed and pragmatic support. Consequently, "The short-comings of the supply economy and of welfare provision

heighten the role of the family as ultimate welfare provider, 'the safety net', with the social and economic support of kin becoming an indispensable resource" (Giza-Polesczuk, 1994: p.228). As Peggy Watson explains:

> The pivotal role of the family ... simultaneously underlines the central importance of women's work, and thereby adds to women's sense of self-worth. It is the family, the domain of women, which becomes of crucial political and economic importance. (Watson, 1992a: p.140).

The private sphere was also crucial for maintaining productive needs. Thus a number of sociologists have documented how goods and services were 'lifted' from the state sector through processes not recognised as stealing and through mechanisms of generalized reciprocal altruism, circulate within *środowiskos* independently of the state sphere. Furthermore it was through these family level contacts that people obtained not only goods, but also bureaucratic and medical services as well as jobs. Thus the private provided access to the public sphere.[6] Because women were frequently employed in interactive positions within these informal links, and able to trade the goods and services to which their jobs gave them access; "the position of women within the formal division of labour in the public domain may belie the social power that position affords them"(Watson, 1992a: p.141).

In conditions of an imposed and alien state where people were made to "feel paltry in the public sphere" (Havelkova, 1993: p.67), the private provided the arena within which to realize existential needs, and orientation towards the private became "an essential, psychologically-formative consequence of the suppression of public subjectivity". Marody explains:

[6] Discussed by Giza-Polesczuk (1994), but also noted through personal observation.

> The meaning of life is sought in bringing up one's
> children, the satisfaction of the need for respect and
> autonomy in actions taken to prevent downward social
> mobility, and the satisfaction of the need for freedom of
> speech in private discussions. (1987: p.151)

So not only was this an arena for substitute economic activity, it
was also the place where people put to use their inventive
potential and desire to do things their own way, without having
to observe official regulations. The family and close friends
substituted for the public sphere in the sense that they provided
the only school of political thought - given the absence of any
opportunity in the media, schools or elsewhere for public
discourse.

Peggy Watson points out how in this situation the importance
of tradition as a cultural resource for self identity is heightened,
as a defense against state institutions; gender identity is one
aspect of this cultural resource. Consequently society's
definition of itself in opposition to the state means a continual
revitalisation of tradition; traditional gender identity is not
suppressed but rather enhanced. It also remains unchallenged
because all problems are attributed to the imposed system rather
than to the social order. She shows from interviews:

> *In Poland* you can't be a mother and an employee.
> Women should not consent to today's exploitation. ... A
> woman's responsibility is to bring up her children and
> look after the family home for them and for her
> husband. Our mothers didn't understand that and our
> generation grew up without them. ... *When conditions in a
> State are as they are here,* and there is such a low level of
> everything which can help a woman, she is unable to
> reconcile her responsibilities under these conditions. ...
> "I'm just waiting till my husband starts to earn more so
> that I can stop working". (Watson, 1992a: p.139)

While the family was elevated and construed "as a harmonious collectivity pitted against the difficulties and strife of coping with the shortcomings of daily life" (Einhorn, 1993: p.59), the public realm was denigrated and unable to provide a source of identity and achievement, let alone the status or economic backing which could lead to authority at work or at home. Barbara Jancar, in her description of work under communism shows how elements of choice, responsibility and individual expression were systematically removed. Thus there is little opportunity for a subordinate to "originate an action, a modification of work practices or a research topic" (Jancar, 1976).

Tarasiewicz, former leader of Solidarity Women's section, also affirms that, "In the communist period work was not considered to be a source of independence." Rather, "Low wages became a kind of substitute for social welfare" (1991: p.183). Hana Havelkowa draws attention to the way career advancement often involves compromising oneself with the party (1993: p.69). This is confirmed by Jancar who reports from research that, "Because of political intrigue and the nature of administrative jobs in those countries, no 'good' woman would want an important job." And the administrative and decision-making positions were seen as the province of already corrupted and corrupting individuals (1985: p.186).

From this point of view the escape to motherhood which women preferred constituted an option not available to men. The right to work was not something women had had to fight for like in the West. In fact it had been "degraded by state compulsion into an obligation to be endured" (Einhorn, 1993: p.114). Finally, as Tarasiewicz explains, "The motivation for most of them was not the hope of fulfilling career ambitions or the intention of being financially independent but a much more mundane need to make ends meet" (1991: p.184).

In the same way, participating at the political level in public decision-making has equally negative implications. As Jancar

reports from her research, "Most people in communist societies consider the party or government bureaucrat to be a socially useless, non-economically-productive person". And what is true of men is doubly true of women:

> If a woman starts a meteoric rise in the party, whether she is married or not, it is taken for granted that she has a 'protector' in the party apparatus. Political prominence for women under communism demands male sponsorship (Jancar, 1976: p.198).

Consequently, as Einhorn points out, there is a "rejection of politics and the public sphere as a 'dirty' business best left to men" (1993: p.157). This was borne out by my interviewees, for example Theresa, who assured me that she would never get involved in politics because it meant that at some point you would have to lie.[7]

Kasia, too, told me in response to the question of why more women didn't involve themselves in politics that:

> Here in Poland the style of dealing with politics is extremely stressful. ... Practising politics here in Poland is mangle-like. I mean one would say it's a little like being put through a mangle - wrangling and blustering, making defamatory remarks, insulting one's opponents, pulling them to pieces. If women united they could be outstanding in politics. But it's difficult to tolerate such an atmosphere. I can say that my women colleagues work in a different way.[8]

The negative perception of politics is a consequence of the role which politics came to play in Polish society; politics in terms of interest representation was simply not part of the Polish imagination. This is because under the communist system there

[7] Interviewee no. 4
[8] Interviewee no. 5

was an absence of representative intermediary institutions as the system was designed to carry orders downwards, rather than for social opinion to influence the state.

In the hostile state environment which results, individuals tended to "turn their attention away from public issues, restricted their participation in secondary groups, and focused instead on the values of private life and the enhancement of their activities in primary groups made up of families and friends" (Kamiński, 1992: p.252). Consequently their relationship towards the state tended to be an exploitative one, as Kamiński explains:

> When individuals and groups decide to exploit existing opportunities, they may become politically active, overtly accepting an ideology that is not theirs, but using their political positions to promote the interests of the family and of allied primary groups. Then, when the political leadership abandons the use of terror, ... informal relations and clique networks start to permeate political institutions, and the phenomenon of the *privatization* of the state begins to escalate. (ibid: p.254).

This in turn leads to the situation described by Nowak, where "between the family and identification with the Polish nation there is a 'social vacuum' with occupational, class, regional and even peer group identifications almost non-existent". (Quoted by Frentzel-Zagórska, 1991: p.167)

Frentzel-Zagórska backs this up by arguing that, while people did identify to some extent with broader social groups, the objects of identification "were not institutions but visible or invisible collectives, treated as distinct from the organisational unit or officially recognised social class. These collectives were perceived as parts of the nation or society as whole" (1991: p.168). This leads to a situation in which family concerns are paralleled by a concern for society as a whole. Furthermore, as pointed out by Peggy Watson (1993) it is women who are most

closely identified with both areas, who are "yoked to family duty and to the identity of the universal", and "speak for the universal against all particular interests".

However the 'universal' is not perceived to be within the realm of politics, which is understood in terms of self interest. This understanding of politics is effectively the opposite of political theorists such as Arendt who, in her discussion of the public realm, sees politics as being precisely concerned with the greater whole:

> For this world of ours, because it existed before us and is meant to outlast our lives in it, simply cannot afford to give primary concern to individual lives and the interests connected with them; as such the public realm stands in the sharpest possible contrast to our private domain, where, in the protection of family and home, everything serves and must serve the security of the life process ... Courage is indispensable because in politics not life but the world is at stake. (1961: p.156).

By contrast, my informants tended to see their actions as non political precisely because they were motivated by greater concerns than 'the life process' - as in the case of Anna, a KOR activist, who was always highly involved in conspiratorial activities and is now a leading political journalist:

> At that time I didn't feel that what I was doing was connected with politics. What's more to the point is that we didn't like communists. It was a moral matter not political. Today it looks as if I was engaged in political activity, but many of the people I have spoken to from those days from KOR saw it as a moral matter not political. ... My participation certainly didn't have any political motives because politics really doesn't interest me. [9]

[9] Interviewee no. 10

Ch.6
THE BUSINESS OF POLITICS

The absence of civil society, private property and access to self
fulfilment in the public domain had different consequences for
men and women. For women it meant a substantial levelling of
relations between men and women, since women did have more
access to the public sphere than for example their sisters in
Britain, and men were deprived of the resources which enabled
them to establish patriarchal relations in the home. While
women's role within the family and friendship groups increased
their labour burden they also "gained extra kudos for
maintaining the informal networks that formed the basis of a
clandestine and embryonic civil society" (Einhorn, 1993: p.45).
Consequently their role within the family and elevated private
sphere may have perhaps made up for the loss of a career (ibid:
p.59).

However men, who had no alternative role to turn to, and
whose authority in the private sphere is often predicated upon
success in the public one, may have felt the restrictions of public
life under state socialism more keenly. As Peggy Watson
explains:

> The opportunities offered by civil society for the
> experience of 'success' were withheld from men under
> State socialism, while careers in the State-run public
> domain increasingly appeared to be devoid of value or
> sense. (1992: p.142)

Consequently the absence of private property, of politics and of
civil society in Poland did not bring about so much "the
neutralisation of the population", as Markus suggested, but

rather "the neutering of men in the public domain" (Watson, *op. cit.*) This is supported by evidence provided by Jacek Kurczewski, who attributed the 'social heterogeneity' of the Solidarity leadership to the fact that a new middle class came into being during the seventies which was disaffected by the lack of opportunities in the formal career structure:

> Since 1980, I have maintained that Communist society produced its own new middle class composed of educated and skilled people, whose aspirations were cut short by the *nomenklatura* barrier, making it impossible for a non-party member, and to a degree for a rank-and-file Party member, to influence his conditions of work and neighbourhood and to participate in political life. This new middle class encompassed skilled electricians as well as university professors, and Solidarity's leadership reflected this occupational and professional heterogeneity.[1]

Consequently, while women's oppositional activities may have been motivated by more outwardly directed moral concerns, for society or the Polish nation, men may have been more motivated by personal goals - as Einhorn suggests.

> Indeed some people have suggested that men felt the need to become prominent in dissent during state socialism as a way of endowing their lives as stokers or janitors with meaning, whereas women - because of their multiple roles - did not need such affirmation. (1993: p.149).

This is confirmed by Szwajcer's observations on opposition activists. Apparently only men satisfied the definition of 'opposition activist' used in the study concerned:

[1] Quoted in Watson, 1993, p.19

> Opposition activists were consumed by the passion of entering public life on their own terms and in entering upon and creating activities in the public sphere. The terms 'activity', 'participation', and 'public sphere' act as guideposts, without which it is impossible to comprehend the Polish Opposition. (Watson, 1993: p.16)

This contrasts markedly with the motives of my interviewees, who spoke repeatedly about their moral and social concerns and the need to overthrow communists, and who, in order to achieve their goal, made a specific effort to evade the glare of the public sphere; hence their effectiveness. It was beyond the scope of my research to compare and contrast the motives of men and women, however it appears plausible that men may have been motivated more by the expressive need to assert themselves in the public sphere and private interests, such as improved promotion chances and wages. And although women were also motivated by the latter, it was subordinate to their concerns for the society as a whole:

> The very low standards and the very low wages in education, health and learning were scandalous. For these areas decided the conditions of the country ... These were key aspects in the country and that's why they were the first and most essential. Afterwards there were the miners and steel workers; everything came afterwards. [2]

> We were fighting for something better for all of us, not only for the health services. [3]

This hypothesis is reinforced by the fact that women predominated in services "on which the conditions of the country depended".[4]

[2] Interviewee no. 15

[3] Interviewee no. 18

It is further backed up by evidence which suggests that women's private role leads to a regard for the world beyond their own private concerns, not just in Poland but in other countries as well:

> Time and again, women spoke to me of wanting only 'to do things to help other people', explicitly and implicitly spurning what they saw as the ruthless self-regard required not just of career women but of participation in public life. Such activity is selfish in the sense that it connects to their children, the world that life with and around the children throws up; unselfish in that it seeks no personal reward or glory for itself. (Benn, 1993: p.2)

It should also be pointed out that because women had been more grounded in the private sphere, they may not have identified as much as men with the past political system and therefore may not have been as affected in the same fundamental way by the traumas and upheaval of transformation as men. As Einhorn explains, unemployment would not have struck so centrally at their identity since they did not hold high-level and therefore the most heavily compromised posts under state socialism. Furthermore, Titkow suggests in another article that women can cope with unemployment better than men because they have this private role to turn to, and the high percentage of male alcoholism seems to bear witness to the difficulties which men have. [5]

Men's desire to reclaim the public political sphere through a return to conventional forms of institutionalised politics is accompanied by a tendency to oust women. This tendency is promoted by the fact that throughout the years of opposition men had a more public status; even if behind internment walls, it was a rather impotent one, whereas, as demonstrated earlier,

[4] Interviewee no. 15
[5] A Titkow in *Gazeta Wyborzca*, 9th April 1996.

women burrowed away behind the scenes. Despite their central role, "Women in the opposition appear more marginal to the organisational structure of the opposition movements, with visibility in leadership depending on male endorsement." (Jancar, 1985: p.15) Consequently post-transition it is men who move ahead, whereas women are left behind.

Women are moreover to a certain extent colluding in their own exclusion, as a renewed emphasis on tradition is maintaining the importance of the private sphere for women today. This is occurring for a number of different reasons. Firstly, just as men felt emasculated under a socialist state system, so women, compelled to work under a false sexual egalitarianism, felt as if they had been unable to realise their feminine identities. These can be realized by re-invoking the traditional family form which, according to Einhorn:

> ... evokes strictly gender-demarcated roles and responsibilities in a hierarchy of male authority and female dependence. The search for untarnished values and identities has leapfrogged the often unpleasant realities of both state socialist and Second World War history, turning instead to the spirit of nineteenth-century or inter-war nationalism. For the family this means reinventing the doctrine of gender segregated spheres. (1993: p.45)

Furthermore, after years of being over-burdened with work *plus* home with its endless domestic chores, many women will welcome with a sigh of relief the opportunity to shed the double or triple burden and to spending a few years at home with the children. They wish to indulge a right they never had - namely the right to choose whether to go out to work or to stay at home.

Finally, Anna Titkow points to the influence of Catholic ideology even before the current transformation in perpetuating

the division between public and private life and confining
women to the latter sphere:

> The Church's influence on defining women's position in
> Polish society, where 75 percent of women are faithful
> and practising Catholics, hardly has to be proven -
> especially when we constantly hear how woman's
> domain is home and family while man's world is his job,
> politics, and all activities outside the family circle. (ibid:
> p.61)

This process appears in an even more accentuated form in
Poland where the transition to a market economy and formal
democracy has been accompanied by the political empowerment
of the Catholic Church.

The way in which both men and women maintain the
patriarchal structures which keep women out of politics
emerged clearly in one of my interviews:

> And it is true that men have more time, and a woman if
> she works also has the family to look after. But also it is
> very hard for the woman to get ahead. ... The biggest
> barrier is that if a woman wants to enter public life she
> must feel acceptance from her family, her friends at
> work, her *środowisko*. And if she doesn't feel that
> acceptance it's very difficult for her. Men pay no
> attention to that sort of thing. That is what I want to do,
> and that is the end of it. Women must feel that the
> family are happy about it - that they will help and not be
> against them. For example I personally didn't start in
> the second round of elections. I resigned because I
> already had a second job and my children wouldn't be
> able to stand the fact that I would be always away from
> home. But my husband never paid any attention to
> these things, the first round, the second round, the third
> ... he never worried about whether the children accepted
> it or not.

Also another factor is that women are incredibly unsure of themselves, and in order to speak in public, to participate in meetings, she has to be 100 percent sure that she is right, that she knows better, that she has checked everything. Men however are much more sure of themselves, and can speak in public even if it is absolute stupidity, and people will vote for them simply because they know them.

Women are brought up to believe that men are head of the family, that men know better, that men know about politics. And women are those who organise the home, who help, make sure that there is something to eat, that children get to school on time and study hard. ... It's a rule. [6]

However the fact that women are to a large extent kept out of mainstream politics should not blind us to the way in which they do contribute. This unfortunately is obscured by the whole transition discourse which tends, as for example in the case of O'Donnell and Schmitter, to give primacy to the actions of political elites.[7] As Georgina Waylen explains:

Within the 1980's model of the political transition to democracy, which has its roots in the competitive elitist view, 'politics' is defined narrowly to include only the upper institutional echelons of the public sphere. Politics then becomes a largely male activity, as women are not part of political elites in great numbers and therefore do not appear to be politically active. (1994: p.333)

This tendency to render women's activities invisible and therefore reduce their influence is in danger of being perpetuated by certain feminist perspectives which see women's

[6] Interviewee no. 13
[7] Discussed in Waylen, 1994: p.330

activity in terms of women's movements. Thus in a country like
Poland where there has been no significant women's movement,
the importance of women's contributions may be under-
estimated. Waylen can conclude that:

> So far, therefore, women's movements have not played
> a significant role in the destruction of the old
> communist order, nor have they influenced the policies
> of the new governments, either in terms of numerical
> representation or policies. (ibid: p.350)

However, women's movements must not be confused with
women themselves. As I have tried to show, they *have* played an
extremely significant role in the destruction of the communist
order. Furthermore not only have they played a significant role
in the destruction of the old but they also continue to be vital in
the building of the new. However, this continues to be at the
decentralised level, where politics appears more accessible and
more able to be combined with domestic and childcare
responsibilities, as one of my informants testified.

> At the level of NGOs there are more women, decidedly
> more women, schools, neighbourhood organisations ...
> All those local level organisations are the responsibility
> of women. They are more active undoubtedly because
> this is an area they know about. These things are for
> them the most important ... And in the Private Business
> Foundation, women constitute 40 percent of the firms.
> But included in that are big businesses and I think, well
> there isn't separate information about small businesses,
> but in those big firms there are almost no women, so I
> think that the smaller firms may be made up of at least
> 50 percent of women. [8]

[8] Interviewee no. 13

Alina Kozińska-Bałdyga, again plagued by a lack of available information, points in the direction of women's possible contribution:

> NGOs have a number of functions which become particularly significant in the period of political transition. The basic functions include the recognition and expression of social needs, and the initiation, activization and organisation of actions aimed at satisfying social needs. People from these organisations become the driving force of the public life in their own communities. They acquire new co-workers and create new organisations.

And although the gender of members is not specified on the registers.

> On the basis of the data from the Warsaw Volunteer centre, founded at the Office for Self-Government Initiatives. ... one may say that out of 120 volunteers, 80 percent were women ... A preliminary analysis of the composition of the boards of NGOs shows, in turn, that women are on an equal footing in them with men. Along with the above conclusion that women have equal opportunities for developing and implementing action programmes in these organisations, the consideration of their specific characteristics provides a basis for the statement that the role of women in post-communist countries may grow, as a result of the increasing function of NGOs in these countries. (Kozińska-Bałdyga, 1995: pp.1-3)

That women are more active at the lower levels is echoed in the findings of Anna Titkow and Joanna Regulska (Titkow, 1992: p.35; Regulska, 1992: p.180) Also, the fact that women have a different way of operating is confirmed by Jancar in her study of women in the opposition:

> She probably favours unstructured, open, and more
> democratic styles of participation rather than the
> traditional organised hierarchies. In her role of
> spokesperson she tends to make symbolic emotional
> appeals rather than rational functional demands.
> Essentially her concerns are centered on the basic issues
> of social and economic rights. (Jancar, 1985: p.184)

The local, less structured level of operating is a feature not only
of women in Central and East European societies but has been
observed in the West as well. Thus Pippa Norris, writing about
Britain, points out that conventional studies "frequently
neglected not only *locus* but also the *modus operandi* of women's
participation".[9]

Likewise Melissa Benn, initially shocked at British women's
"deep estrangement from formal, traditional politics", ends up
concluding:

> If I replay my interview tapes - skipping the formal and
> strained question-answer on politics - I hear about a
> welter of private and public activity: playgroups,
> schools, single parent self-organisations. For these
> women, it is activity at a level that feels comfortable.
> (1993: p.24)

Therefore while the effort to get women into public life should
certainly pay attention to mainstream politics, as did Grażyna
who is involved in a group which provides support to women
wanting to enter at this level,[10] a far more encompassing
approach is also needed. This involves drawing attention to, and
revealing the political importance of, all levels of social activity
and creating the kind of environment in which this local level,
through non-governmental organisations, can have a crucial
role.

[9] Quoted in Einhorn, 1993: p.164-5
[10] Interviewee no. 13

This is important not only in enabling women to have a greater role in public life but it also appears to be the direction in which many commentators on transition think we should move. Thus Wesołowski advocates a move towards the more communitarian type of bond which takes groups rather than the social contract individual as the unit of society. This he argues is more appropriate in a political culture which rests on a socialist legacy added to Catholic concept of community. This communitarian type of approach exists where:

> The common form of life is seen as a supremely important good so that its continuance and flourishing matters to the citizens for its own sake and not just instrumentally to their several individual goods or as the sum total of these individual goods. (Wesołowski, 1995: p.132)

As I have tried to indicate, this is also an approach shared by women. Kuron too sees the local group level as having a particular role to play in the transformation, arguing that "It is now time to return to group activity so as to design and implement specific programmes". (Rychard, 1993: p.150) Andrzej Rychard points in a similar direction himself when he hopes that:

> The evolution from macro-politics to a 'micro-society' will result, finally, in the creation of a new kind of politics rooted rather than imposed. (ibid: p.163)

The development of a local level political life will not only enable women to have a greater input in the public sphere; it will also put mainstream politics more in touch with local level needs, and enable it to respond to the way in which everyday life works rather than determining it. As this level of activity becomes more important, it may draw men away from traditional political hierarchies, thus allowing more women their positive input into this sphere.

The absence of women 'at the top', whether of politics or the employment market, fuels the feminist fire. The argument in this essay is not based so much on a critique of the unequal representation of women and men at the higher echelons of hierarchies, but rather it is a critique of a social order which allows power to be concentrated in one area. What the study calls for is recognition of the vast resources of power which lie at the hidden, lower, private levels.

However this is *not* done in order to condone gender segregated spheres. Rather it is done in order to promote the view of a social order in which the private level is an equally, if not more, valid social sphere. I have tried to do this by showing how the political actually emerges from the private in contradiction to those views which see the private realm as concerned only with private interests. Drawing attention to the importance and vitality of the private level justifies moves away from mainstream politics, and recognises this as the way forward to increasing equality at both the private and the public levels.

APPENDIX A

THE INTERVIEWS

Twenty seven interviews were carried out between April and July 1996. Twenty two of these have been used here; the others have been left out because of inadequate recordings. Of those used twenty one were with women, and one with a man, Zbigniew Bujak, who I discovered from my other informants had had a lot of contact with women in the Underground.

Women were selected on a snowballing basis, with one contact leading to another, as shown in the following diagram. Initial contacts are shown on the left. Where an *unused* interview led to further contacts I have represented it with a star.

1.	2.	15.	9.	
	6.			
3.	4.	5.	7.	12.
8.				
*	11.			
	16			
	17			
	19			
	18			
13	10			
*	20			
	14			
21.				

I have been unable to ascertain the intensity of these Underground contacts in greater detail. But these preliminary findings, and the frequent references which one informant would make about another belonging in a different 'chain', suggest that the Underground was in fact a closely linked environment.

Questionnaire

The interviews were largely open ended. However, the following list of questions guided the conversations:-

1. What was your first action which was in some way against the authorities?

2. What motivated you to get involved in oppositional activity?

3. What activities were you involved in?

4. How did you balance your family responsibilities and Underground activities.

5. How did you manage in every day terms; how did you survive?

6. Did men and women have different roles? (9 'no's and 3 'yes's (including the one male informant) to this: the rest were undecided)

7. How much contact did you have with your neighbours?

8. How did family responsibilities influence a woman's ability to participate?

9. What sort of contact was there between leadership and masses?

10. Do the networks formed in the Underground period still exist? (No 'yes's)

11. What kind of influence does what you did in the Underground have on what you do now?

All interviews except 3, 4 and 16 were conducted in Polish. If there were ever any doubts as to the content of the material it was not used. Only material where I could very clearly understand what was being said was used.

APPENDIX B

THE INFORMANTS

In order to maintain the anonymity of interviewees some details, including names, have been changed. This principle has been abandoned in the case of Zbigniew Bujak (no. 22) who has chosen to have a public role and did not feel the need to remain anonymous for the interview. Ages are often approximated; women do not like revealing their age. The details 'Marital status' and 'To care for' refer to the interviewees' situation during the 1980's. A person's educational background will be added in brackets after their name if known.

1.

Name: Bożena (journalism)
Age: 39
Job in 1981: Journalist for Pax (from 1980)
Job from 1981 to 1989: Maternity leave 1985, then she started working again for Pax, then for the Solidarity studio in 1987.
Current job: Journalist /Director at Polish Television.
Marital status: Married
To care for: Mother-in-law with Alzheimers and baby daughter.
Earliest conspiratorial activity: Not mentioned
Involvement with Solidarity: She joined the union and was able to write much more freely as a consequence of Solidarity.
Conspiratorial activities: She "internally migrated" by becoming pregnant and that way "stayed clean". She became involved with Underground journalism in 1985, when her daughter was nursery school age.
Internment: No
Current political activity: None

2.

Name: Dorota
Age: 55
Job in 81: Journalist/Director at Polish Television
Job from 1981 to 1989: Worked in a flower shop
Current job: Journalist Director at Polish Television
Marital status: Married
To care for: Two teenage children
Earliest conspiratorial activity: Not mentioned
Involvement in Solidarity: Helped to organise Union at television.
Conspiratorial activities: Set up an employment bureau for unemployed journalists. Was involved in food distribution, discussion clubs connected with the church where they discussed such topics as the new constitution. She made videos of talkshows for the Underground. Illegal home theatre, art exhibitions and video shows at her house. Passed on literature.
Internment: No
Current political activity: None

3.

Name: Irena (English Philology)
Age: 48
Job in 1981: English Teacher at the Polytechnic
Job from 1981 to 1989: As above
Current job: As above
Marital status: Married
To care for: One young child
Earliest conspiratorial activity: Not known.
Involvement in Solidarity: Involved in Solidarity meeting, discussed the ways in which they could be more independent from the party in order to organise things, eg the syllabus, better. Gave support to striking students. Was prepared to strike herself.
Conspiratorial activities: Passing on Underground literature, and videos, collecting money for out of work actors and people in need. Gave support to those organising medical aid. Shared food parcels. Participated in passive resistance e.g masses for the fatherland, going for walks when the news was on, flashing lights in unison to show one had heard Radio Solidarity.

Internment: No
Current political activity: None

4.

Name: Ewa (English Philology)
Age: 46
Job in 1981: English Teacher
Job from 1981 to 1989: English Teacher
Current job: English Teacher
Marital status: Divorced
To care for: One young child
Source of income: English teaching, glass and egg painting
Earliest conspiratorial activity: Was involved with KOR, through her students. Read and passed on materials.
Involvement with Solidarity: Helped to organise the teachers union. Printed and distributed leaflets. Supported new cultural activities. Supported student strikes.
Conspiratorial activities: Published, printed and distributed leaflets. Arranged meetings every Tuesday at her flat as a way of maintaining contact when telephones were cut. These were later changed to first Friday of the month parties. Worked at an art gallery at the Arch diocese museum where they had exhibitions and concerts. Was also involved in providing support structures to French medical aid and arranged contacts between French journalists and leading politicians. Was involved in an independent polling count for elections and in publishing the findings underground. Collected money for Solidarity. Was part of the support structure for the Citizens Committee.
Internment: No
Current political activities: She publishes the Solidarity bulletin at her place of work.

5.

Name: Kasia (engineering)
Age: 60
Job in 1981: Teacher at the Polytechnic
Job from 1981 to 1989: Teacher at the Polytechnic
Current job: Teacher at Polytechnic

Marital status: Single
To care for: Lived with her brother
Source of income: Teaching
Earliest conspiratorial activity: Postwar scouts
Involvement in Solidarity: Member of the Union. Helped to prepare for strikes (which never happened) in 1981 including organising food and medical provision.
Conspiratorial activities: Relating to radio, television transmission techniques (she is an engineer), also part of the underground committee at the polytechnic; she was particularly involved in organisational aspects, with the information and publishing houses. She was involved in liaising between the illegal Solidarity and those in the legal Polytechnic authorities. Transportation, reception and distribution of medicines. Helped brother; a leading Solidarity activist. Helped work on drafts which were being prepared for improvements in the higher education system. Organised meetings at her flat which was a convenient location because it had two different entrances.
Internment: Brother interned.
Current political activities: She is a member for the main committee of Higher Education. She works for the Solidarity Mazowsze regional Committee.

6.

Name: Elżbieta
Age: 65
Job in 81: Worked for National Radio abroad.
Job from 81 to 89: Helped to run a shop set up by the Journalists Association. Then she worked for the Sports Institute.
Current job: Retired
Marital status: Married
To care for: Two teenage children
Source of income: Her job and benefits from sickness retirement.
Earliest conspiratorial activity: None till '81 (Had been a party member till then)
Conspiratorial activity: Participated in food and leaflet distribution organised by the Journalists Association.
Internment: Son interned for two weeks.
Current political activities: None

7.

Name: Grażyna (Sociologist)
Age: 40 - 45
Job in 1981: Worked for the Government Institute for Training Civil Servants.
Job from 1981 - 1989: Editor of sociology and philosophy journal, when Solidarity was legalised she worked for the National Commission.
Current job: Solidarity National Commission.
Marital status: Separated
To care for: One young child, two ill grandparents.
Source of income: Making jewellery, small amount of money from husband, grandfather's social security benefits, low wages from work.
Earliest conspiratorial activity: Building a student house in the forest for meetings.
Involvement in Solidarity: Organised a Solidarity Union at her place of work. 100 out of 300 joined. Gained some autonomy for the institute through the union, describes herself as having been very involved.
Conspiratorial activity: None due to family situation, was however elected to Solidarity National Commission when it was legalised.
Internment: No
Current political activity: Works for Solidarity.

8.

Name: Joanna (Sociologist)
Age: 45
Job in 1981: Worked at the University; involved in research into Solidarity.
Job from 1981 - 1989: Worked at the University. While there conducted research into strikes. Was an advisor for Śląsk region at the round table negotiations.
Current job: Job connected with local level democracy.
Marital status: Married
To care for: One young child
Source of income: Husband in a well paid job (was a former party member). Her own University job.
Earliest conspiratorial activity: Member of a non-political student's union.

Involvement in Solidarity: Helped to organise training schemes in places of work and conducted research into participation.

Conspiratorial activity: Carried on previous training work to a certain extent after martial law. She gave lectures on International Trade Unions, and was a coordinator for the training. She also helped to maintain contacts between Underground unions. *Tygodnik Mazowsze* was based at her flat for a long time.

Internment: No

Current political activity: None mentioned

9.

Name: Krystyna

Age: 40 - 45

Job in 1981: Was a journalist for a health service newspaper.

Job from 1981 - 1989: Some very trivial job, purely to appear to be employed.

Current job: Chief Editor of the same newspaper.

Marital status: Single

To care for: One young child

Source of income: Benefits for single mothers, a helpful aunt in Germany and her parents also helped her.

Earliest conspiratorial activity: Don't know

Involvement in Solidarity: Participated in strikes of the health services in Gdańsk and tried to write honest articles about them.

Conspiratorial activities: Agency of Printing and Press in the Solidarity Commission. Participated in strikes of and wrote articles on issues connected with the health service. Was in charge of the Bureau for Inter-regional Contacts. Kept a wholesale storage of books and newspapers in her flat. Carried pamphlets, wrote articles, typed bulletins.

Internment: No

Current political activity: None

10.

Name: Anna (law)

Age: 49

Job in 1981: Worked at a printers

Job from 1981 - 1989: Unemployed most of the time, although at one point she worked for a film director.
Current job: Journalist at *Gazeta Wyborcza.*
Marital status: Divorced
To care for: One child (teenage)
Source of income: Disability allowance, articles for foreign newspapers, a sister abroad who helped a little, a small alimony from her husband.
Earliest conspiratorial activity: KOR member, also involved with Nowa.
Involvement with Solidarity: Worked as a journalist; main writer for shipyard bulletin *Stocznia.*
Conspiratorial activities: Selling books, transporting them. Maintained a broad network of communication from her KOR days, and this enabled her to supply information. She set up a bulletin on information about repression. Was involved with *Tygodnik Mazowsze*, Solidarity newsletter, main writer for bulletin '*Stocznia*' (while Solidarity was still legal). Found flats for people. Ran an information bureau about the strikes in '88 which supplied foreign newspapers with information.
Internment: No
Current political activity: A Political Journalist

11 .

Name: Wera (Nursing)
Age: 55 (approx)
Job in 1981: Nurse
Job from 1981 - 1989: Nurse
Current job: Nurse
Marital status: Widow
To care for: One teenage son
Source of income: Employment
Earliest conspiratorial activity: Had been active in KPN.
Involvement with Solidarity: Helped to set up union at her place of work. She was secretary of the Commission. Tried to use the union rights which already existed (from before Solidarity). Went to Ursus to try to help set up unions there.
Conspiratorial activity: Helped maintain communications between the health services all over Poland. This was an important source of

contact for all Underground activity because it was the only telephone line which couldn't be shut down. She worked on the Solidarity coordinating committee. Organisational activities.
Internment: No
Current Political Activity: None

12.

Name: Monika
Age: 49
Job in 1981: Distribution of physics text books.
Job from 1981 - 1989: Worked in a factory which made lamps. Then she found technical work at the University.
Current job: Social and Political affairs in the Solidarity Country Commission.
Marital status: Single
To care for: Two very ill parents
Earliest conspiratorial activity: March 1968
Involvement with Solidarity: Involved in setting up a circle of Solidarity activists at her place of work. Soon cooperated with Mazowsze region. Was involved in consultation, mediation & intervention. She worked as a consultant helping other areas to set up union structures, helped people read and understand the statutes.
Conspiratorial activity: Passed on literature and information, worked at a publishers, collected money, prepared packages for people. She was a member of the Committee of Intervention from 1986. She was involved in the Union structure at the University, and in Mazowsze Regional Branch.
Internment: Yes, for six months. She was also imprisoned 5 or 6 times
Current political activity: Member of the Solidarity Country Commission praesidium, responsible for social and political affairs.

13.

Name: Beata (Slavonic Philology)
Age: 45 - 50
Job in 1981: Worked at PAN
Job from 1981 - 1989: Unemployed

Current job: Works for Institute for Building Local Democracy, and for Ford Foundation.
Marital status: Married
To care for: Three young children
Source of income: Received support for families of interned activists. Husband's University wages.
Earliest conspiratorial activity: Involved in 1968, and student discussion groups prior to this.
Involvement with Solidarity: Provided support for husband who was a leading activist.
Conspiratorial activity: Provided support to her interned husband; saw herself primarily as a helper. Carried press and information. Was prevented from being more involved because of her husband's public status. Was subsequently involved in the Citizens Committee; she was elected to self government.
Internment: Husband was a long term internee.
Current political activity: Following on from Citizens Committee was involved in setting up the first integrated school in Poland and organised various actions related to this. Works for an organisation which helps women to get into politics.

14.

Name: Mariola (Religious training, philosophy)
Age: 60
Job in 1981: Journalist for *Tygodnik Powszechny* and *Znak*
Job from 1981 - 1989: Journalism.
Current job: Editor of *Polis*
Marital status: Married mid '80s
To care for: Sick mother
Source of income: Don't know
Earliest conspiratorial activity: Girl Guides after war, before Stalinisation.
Involvement with Solidarity: Wrote protocols for discussion with management, worked as an advisor, union training e.g role play, printing posters, discussion, organising meetings.
Conspiratorial activities: Maintained contact with those interned all over the country, kept them in contact with the organisation. Distribution of food, helped look after families of those who had been interned.

Internment: Interned for ten days
Current political activity: Editor of a magazine whose concern is, effectively, 'Civil society'.

15.

Name: Teresa (law)
Age: 48
Job in 1981: Worked in an organisational capacity at the medical academy.
Job from 1981 - 1989: As above. Following the transition was made the Vice-minister of health.
Current job: In charge of the personel department at Polish Television.
Marital status: Single
To care for: No-one mentioned
Source of income: Through employment
Earliest conspiratorial activity: Participated in strikes in '68.
Involvement with Solidarity: With a group of people organised Solidarity in her place of work. Became involved in the Poznań Regional Committee. Helped to start a branch structure of the health service (hospitals and education; this apparently co-existed with Solidarity's regional structure). She was elected head of the union at the medical academy and this led to her being a member of the health services National Commission.
Conspiratorial activity: Tried to find places for those in hiding. Started to organise a whole first regional and then nationwide Underground structure. Was in charge of two Underground publishing houses. Involved in the printing and distribution of a range of material. Collected money and organised food parcels to help families of those interned. Was involved in organising visits from the West.
Current political activity: Seemingly not involved in politics since she stopped being vice-minister of health.

16.

Name: Maria
Age: 60
Job in 1981: Journalist
Job from 1981 to 1989: Lost her job with martial law.

Current job: Works as a tourist guide for trips abroad
Marital status: Married
To care for: One teenage Son
Source of income: Apparently almost none.
First conspiratorial activity: Not known
Involvement with Solidarity: Became a member of the Union of Journalists, helped organise meetings between Solidarity and party members.
Conspiratorial activity: Organised history lessons. Organised food distribution and help to needy families in connection with the Journalists Association. Also involved in the distribution of medicines Helped organise contacts with foreign journalists.
Internment: No
Current political involvement: None

17.

Name: Agnieszka
Age: 50
Job in 1981: Was a journalist for a magazine in a large state publishing firm.
Job from 1981 - 1989: Wrote cultural items for a magazine for country women.
Current job: Journalist for *Gazeta Wyborcza*.
Marital status: Single
To care for: Elderly aunt
Source of income: Money from sickness benefits, then was subsequently re-employed at the magazine mentioned above.
Earliest conspiratorial activity: Not known
Involvement with Solidarity: Participated in the Journalists Association from the outset.
Conspiratorial activity: Through the Journalists Association provided help for families of unemployed journalists in her neighbourhood (food parcels etc). Worked at St Anne's Church (lent by the Church to the Journalists Association) organising the distribution of clothes and food.
Internment: No
Current political activity: None

18.

Name: Małgosia (Nursing)
Age: 59
Job in 1981: Worked as an analyst in a hospital.
Job from 1981 - 1989: Unemployed
Current job: Works for Solidarity in connection with the health service.
Marital status: Widowed in 1985
To care for: Two teenage sons
Source of income: Husband worked for a state firm, knitted sweaters which were sold through her family to people in Austria (as well as Poland).
Earliest conspiratorial activity: Nothing specific mentioned
Involvement with Solidarity: Helped to organise a Solidarity Union at her place of work. Went down to the hospital in Ursus and helped to set one up there. Within the union concerned themselves with workers pay and reform of health service.
Conspiratorial activity: Attended protests. Involved in help for interned families. Organised medical services at the masses for the fatherland. Organised the collection and distribution of medicines. Acted as a courrier carrying press, books, leaflets. Kept neighbours informed of political activities.
Internment: No
Current political activity: Highly involved in all political actions of the health service. Has been involved in hunger strikes and television discussions. Organises protests.

19.

Name: Hanka (medicine)
Age: 50
Job in 1981; Psychiatrist
Job from 1981 - 1989: Psychiatrist
Current job: Psychiatrist
Marital status: Widowed in the eighties.
To care for: Two young children
Source of income: Her job
Earliest conspiratorial activity: Not mentioned.
Involvement in Solidarity: Joined the Union at her place of work.

Conspiratorial activity Hid people in the hospital.Worked for the Primate's Committee; provided medical aid to those interned.
Internment: Her husband
Current political activity: None
(details of this tape incomplete due to faulty recording)

20.

Name: Janina (Art History)
Age: 65
Employment in 1981: PAN
Employment 1981 – 1989: ditto
Current job: Retired
Marital status: Single
To care for: Not mentioned
Source of income: Job
Earliest conspiratorial activity: Involved in '68, on account of a book she had written on the play *Dziadek*. Subsequently became a member of KOR.
Involvement in Solidarity: Helped to organise Solidarity at her place of work. Was involved in normal union functions; defence of workers, wages etc.
Conspiratorial activity: Provided help for the families of those interned through the Primate's Committee. Helped with organising parcels, finding the addresses of those who were interned, find defence lawyers. Couldn't be more involved because of her own public status as a member of KOR.
Internment: Was interned for two months.
Current political activity: None

21.

Name: Elżbieta (French and German)
Age 44
Employment in 1981: Started working for Polish television as a journalist.
Employment from 1981 - 1989: Polish television; specialised in helping foreign broadcasters (she is a qualified translator).
Current job: Director at Polish television.

Marital status: Single
To care for: Not mentioned
Source of income: Through work at Polish television.
Earliest conspiratorial activity: Typing up material for a KOR newsletter.
Involvement with Solidarity: Was a broadcaster at the shipyards. Was involved in the group of ten people who started up Solidarity at Polish television.
Conspiratorial activity: Helped to smuggle a television into the country with the aim of doing their own independent broadcasting. Moved information to foreign countries.
Internment: No
Current political activity: None

22.

Zbigniew Bujak, Born 1954.
Worker and leader of Mazowsze Solidarity.

BIBLIOGRAPHY

Arendt H (1989) *The Human Condition,* Chicago: University of Chicago Press.

Arendt H (1961) *Between past and Future,* New York: Viking Press.

Benn M (1993) 'Women and Democracy: Thoughts on the last Ten Years', *Women: A Cultural Review* Vol. 4, Oxford: University Press.

Bernard M (1993) 'Civil Society and Democratic Transition in East Central Europe', *The Political Science Quarterly,* Vol. 108, no. 2.

Bialecki I (1982) 'Solidarity – The Roots of the Movement', *Sisyphus Sociological Studies: Crises and Conflicts - the Case of Poland 1980-81,* Warsaw: PWN Polish Scientific Publishers.

Bielecki Ł (2002) *A Brief History of Poland Over the Last 200 Years,* www.polishroots.org/genpoland/polhistory.htm

Black J L, Strong J W and Federowicz J (eds) (1986) *Sisyphus and Poland: Reflections on Martial Law,* Winnipeg: RP Frye.

Brown B (1994) *The Cross-Cultural Limitations of Feminist Theory,* Unpublished paper, Graduate School for Social Research, Polish Academy of Sciences, Warsaw.

Brown B (1995) *The Family: A Barrier or Bridge to Civil Society?* Unpublished paper, Warsaw: Central European University.

Brown B (1996) *Understanding the Apparent Absence of Feminism in Poland,* Unpublished paper, Warsaw: Central European University.

Brown B (1996b) *Why Matka Polka, Superwoman and Cinderella are not Feminism Friendly,* Unpublished paper, Warsaw: Central European University.

Brown B (1997) *Civil Society and the Private Sphere: The Role of Women in the Polish Revolution,* London: Political Science Association Women's Group Annual Conference.

Bryant C G and Mokrzycki E (1995) *Democracy, Civil Society and Pluralism in comparative Perspective: Poland, Great Britain and the Netherlands,* Warsaw: IFiS Publishers.

Buck et al (2002) *Working Capital: Life and Labour in Contemporary London,* London: Routledge.

Bystydzienski J M (ed) (1992) *Women Transforming Politics: Worldwide Strategies for Empowerment,* Bloomington and Indianapolis: Indiana University Press.

Chirot D (ed) (1989) *The Origins of Backwardness in Eastern Europe: Economics and Politics from the Middle Ages until the Early Twentieth Century,* London: University of California Press.

Cirtautas A and Mokrzycki E (1993) 'The Articulation and Institutionalization of Democracy in Poland' *Social Research,* Vol. 60, No. 4, pp.787-819.

Cirtautas A (1997) *Polish Solidarity Movement: Revolution, Democracy & National Rights,* London: Routledge.

Corrin C (1992) *Superwoman and the Double Burden: Women's Experience of Change in Central and Eastern Europe and the former Soviet Union,* London: Scarlet Press.

Davies N (1983) *God's Playground: A History of Poland Vol. II 1795 to the Present,* Oxford: Clarendon Press.

de Seve M (1994) *Youth, Dissent and Transition:Gender's Not so Silent Part* Unpublished paper, Quebec: University of Quebec Montreal.

Dench G (1996) *Transforming Men: Changing patterns of Dependency and Dominance in Gender Relations,* New Brunswick: Transaction Publishers.

Dench G (ed) (1997) *Rewriting the Sexual Contract,* London: Institute of Community Studies.

Dunayevskaya R (1985) *Women's Liberation and the Dialectics of Revolution: Reaching for the Future,* Atlantic Highlands: NJ Humanities Press International.

Einhorn B (1993) *Cinderella goes to Market: Citizenship, Gender and Women's Movements in East Central Europe,* London: Verso.

Ekiert G (1993) 'Democratization Processes in East Central Europe: A Theoretical Recondiseration' *British Journal of Political Science* Vol. 21 pp. 285-313.

Elliott J and Chittenden M (2003), 'Women choose to have lower pay than men', *The Guardian*: London, 6th April.

Federowicz J (1986) 'The Once and Future Commonwealth', in Black J L, Strong J W and Federowicz J (eds) *q.v.*

Frentzel-Zagórska J (1990) 'Civil Society in Poland and Hungary', *Soviet Studies,* Vol. 42 no. 4.

Frentzel-Zagórska J (1991) 'The Road to a Democratic Political System', in *Post Communist Eastern Europe,* Warsaw: Polish Academy of Sciences Manuscript.

Fuszara M (1993) 'Prace Kobiet', *Pełnym Głosem,* nr. 1 lato '93, Fundacja Kobieca eFKa.

Garton Ash T (1991) *The Polish Revolution,* London: Granta Books.

Giza-Polesczuk A, (1994) 'The Strategies of Family formation: Poland and the Western Countries', in Alestalo M, Allardt E, Rychard A and Wesołowski W (eds) *The Transformation of Europe: Social Conditions and Consequences,* Warsaw: IFiS Publishers.

Glinski P (1993) 'Social Actors in Transformation', *Sisyphus* 2 (XI).

Habermas J (1994) *The Structural Transformation of the Public Sphere: An Enquiry into a Category of Bourgeois Society,* Cambridge: Polity Press.

Hall J (ed) (1995) *Civil Society, Theory, History, Comparison,* Cambridge: Polity Press.

Havelokova H (1993) 'A Few Pre-Feminist Thoughts', in Funk N and Mueller M (eds) *Gender Politics and post Communism: Reflections from Eastern Europe and the Soviet Union,* London: Routledge.

Heitlinger A (1979) *Women and State Socialism; Sex Inequality in the Soviet Union and Czechoslovakia,* London: The Macmillan Press.

Hemmerling Z and Nadolski M (1994) *Opozycja Demokratyczna w Polsce 1976 – 1980 Wybor Dokumentow,* Warsaw: Wydawnictwa Uniwersytetu Warszawskiego.

Home Office (1997) *Supporting Families,* London: HMSO.

Hoffman E (1993) *Exit into History: A Journey Through the New Eastern Europe,* London: Heinemann.

Iwańska A (1995) *Kobiety z Firmy: Sylwetki pięciu Kobiet z AK pracujących w Wywiadzie I Kotrwywiadzie,* London: Polska Fundacj Kulturalna.

Jancar B (1976) *Women Under Communism,* Baltimore: John Hopkins University Press.

Jancar B (1985) 'Women in the Opposition in Poland and Czechoslovakia in the 1970s in Poland', in Wolchik L and Meyer A (eds) *q.v.*

Jankowska H (1991) 'Poland: Abortion, Church and Politics in Poland', *Feminist Review,* Special Issue 'Shifting Territories and Europe', Vol. 39, Winter.

Jawłowska A (1994) 'Za szklana ściana', *Pełnym Głosem,* nr 2 jesień .

Jaworski R (1992) 'Polish Women and the Nationality Conflict in the Province of Posen at the Turn of the Century', in Pietrow-Ennker B and Jaworski R (eds) *q.v.*

Kamiński A (1992) *An Institutional Theory of Communist Regimes: Design Function and Breakdown,* San Francisco: California University Press.

Kasprzyk M (1997) *The History of Poland,* www.kasprzyk.demon.co.uk

Kenney P (1995) 'The Gender of Resistance in Communist Poland: A Moral Community Approach', *The American Historical Review,* Vol. 104:2 (April 1999) pp. 399-425

Kickova Z and Farkasova E (1993) 'The Emancipation of Women: A Concept that Failed', in Funk N and Mueller M (eds) *Gender Politics and Post Communism; Reflections from Eastern Europe and the Former Soviet Union,* New York: Routledge.

Kiss E (1992) 'Democracy Without Parties', *Dissent:* Spring.

Kochanowicz (1989) in Chirot D *q.v.*

Koralewicz J (1987) 'Changes in Polish Social Consciousness during the 1970s and 1980s: Opportunism and Identity', in Koralewicz J, Bialecki I, Watson M (eds) *q.v.*

Koralewicz J, Bialecki I, & Watson M (eds) (1987) *Crisis and Transition in Polish Society in the 1980s,* Oxford: Berg Press.

Kozińska-Bałdyga A (1995) *Women in Public Life,* Unpublished manuscript, Graduate School for Social Research, Polish Academy of Sciences, Warsaw

Kurski J (1991) *Lech Walesa: Democrat or Dictator,* Oxford: West View Press.

Laba R (1991) *The Roots of Solidarity: A Political Sociology of Poland's Working Class Democratization,* Princeton NJ: Princeton University Press.

Lee, E (2002) 'Should private life be the subject of public policy', Institute of Ideas Conference, *Private Lives, Public Policy, Marriage, Relationships and Commitment in Singleton Society,* London July 20 2002.

Long K S (1996) *We all fought for Freedom: Women in Poland's Solidarity Movement,* Boulder: Westview Press.

Longworth P (1992) *The Making of Eastern Europe,* Basingstoke: Macmillan.

Lorence-Kot B (1992a) 'Konspiracja: Probing the Topography of Women's Underground Activities: The Kingdom of Poland in the Second Half of the Nineteenth Century', in Pietrow-Ennker B and Jaworski R *q.v.*

Lorence-Kot B (1992b) *Polish Child-Rearing and Reform: a Study of the Nobility in Eighteenth-Century Poland,* Westport, Conn: Greenwood Press.

MacIver RM (1950) *The Ramparts We Guard,* New York: Macmillan.

Marody M (1987) 'Social Stability and the Concept of collective Sense', in Koralewicz J, Bialecki I and Watson P (eds) *q.v.*

Marody M (1992) 'The Political Attitudes of Polish Society in the period of Systematic Transitions', in Connor W D and Ploszajski (eds) *Escape from Socialism: the Polish Route,* Warsaw: IFiS Publishers.

Marody M (1993) 'Why I am Not a Feminist: Some Remarks on the Problem of Gender Identity in the United States and Poland', *Social Research,* Vol. 60, no. 4.

Marody M (1995) 'Life Strategies in the Emerging Capitalist Economy and the Role of Gender', *Polish Sociological Review* 2. 95.

Mason D (1985) *Public Opinion and Political Change in Poland 1980-1982,* Cambridge: Cambridge University Press.

Moore H (1988) *Feminism and Anthropology, Cambridge:* Polity Press.

Morecka Z (1980) 'Women in employment: facts and figures', in *Work and Family Life: the Role of the Social Infrastructure in Eastern European countries,* Geneva: ILO.

Mur J (1984) *A Prisoner of Martial Law, 1981 – 1982*, London: Harcourt Brace /Jovanowich Publishers.

Nagengast C (1991) *Reluctant Socialists, Rural Entrepreneurs, Class, Culture and the Polish State*, Boulder Colorado: Westview Press.

Nelson D (1985) 'Women in Local Communist Politics in Romania and Poland', in Wolchik L and Meyer A (eds) *q.v.*

Okin S M (1989) *Justice, Gender and the Family*, London: Basic Books.

Ortner S B (1974) 'Is Female to Male as Nature is to Culture?' in Rosaldo M Z and Lamphere L *Women Culture and Society*, Stanford: California U P.

Ost D (1990) *Solidarity and the Politics of Anti-Politics: Opposition and Reform in Poland Since 1968*, Philadelphia: Temple University Press.

Pawlik W (1992) 'Intimate Commerce' in Wedel J *The Unplanned Society: Poland During and After Communism*, New York N.Y: Columbia University Press.

Penn S (1993) 'The National Secret', *The Journal of Women's History*, Autumn Issue.

Pietrow-Ennker B and Jaworski R (eds) (1992) *Women in Polish Society*, East European Monographs, Boulder: Distributed by Columbia University Press.

Pietrow-Ennker B (1992) 'Women in Polish Society: A Historical Introduction', in Pietrow-Ennker B Jaworski R (eds) *q.v.*

Pine F (1994) 'Privatisation in Post-Socialist Poland: Peasant Women, Work, and the Restructuring of the Public Sphere', *Cambridge Anthropology* 17:3, 1994

Poland online, http://www.polandonline.com/history.html, ®1997 InterPromo Inc.© (Wroclaw - New York - Paris)

Polish Committee of NGOs (1995) 'The Situation of Women in Poland,' *World Congress of Women*, Beijing.

Politcha K (1993) 'To nie Jest walka, tylko dobijanie się o własne prawa', *Pełnym Głosem*, nr. 1, lato '93, Fundacja Kobieca eFKa.

Ramet S (1995) *Social Currents in Eastern Europe, the sources and the Consequences of the Great Transformation*, Durham: Duke University Press.

Reading A (1992) *Polish Women, Solidarity and Feminism,* Basingstoke: Macmillan.

Regulska J (1992) 'Women and Power in Poland; Hopes or Reality', in Bystydzienski J M (ed) *q.v.*

Regulska J (1993) 'Transition to Local Democracy: Do Polish Women Have a Chance?' in Ruschemeyer M E (ed) *q.v.*

Rowbotham S (1969) 'Women's Liberation and the new Politics', Mayday Manifesto: pamphlet 4.

Ruschemeyer M E (ed) (1994) *Women in the Politics of Post Communist Eastern Europe,* New York: M.E. Sharpe Inc.

Rychard A (1993) *Reforms, Adaptation and Breakthrough: The Sources and Limits to Institutional Changes in Poland,* Warsaw: IFiS Publishers.

Schopflin G (1994) *Politics in Eastern Europe 1945-1992,* Oxford: Blackwell.

Scott H (1976) *Women and Socialism: Experiences from Eastern Europe,* London: Alison and Busby.

Siemieńska R (1994) 'Polish Women as the Object and Subject of Politics during and after the Communist Period', in Nelson B J and Chowdhury N (1994) *Women and Politics Worldwide,* New Haven: Yale UP.

Siklova J (1993) 'Are Women in Central and Eastern Europe Conservative?', in Funk N and Mueller M (eds) *Gender Politics and Post Communism; Reflections from Eastern Europe and the Former Soviet Union,* New York: Routledge.

Sokołowska M (1976) 'The Woman Image in the Awareness of Contemporary Polish Society', *Polish Sociological Bulletin,* Vol. 3.

Sokołowska M (1981) 'Women in Decision Making Elites', Warsaw: Polish Academy of Science Manuscript.

Sokołowska M (1982) 'Health as an Issue in the Workers' Campaign', *Sisyphus Sociological Studies: Crises and Conflicts, The Case of Poland 1980-81,* Vol. iii, Warsaw: Polish Scientific Publishers.

Staniszkis J (1984) *Poland's Self-Limiting Revolution,* Princeton: New Jersey University Press

Staniszkis J (1992) *The Ontology of Socialism,* Oxford: Clarendon Press.

Swidlicki A (1988) *Political Trials in Poland 1981 – 1986,* London: Croom Helm.

Sczeszna J (1990) *Women in the Opposition,* Unpublished Manuscript. USA.

Szymański L (1982) 'Candle for Poland: 469 Days of solidarity', *Stokvis Studies in Historical Chronology and Thought Number Two,* San Bernadino: The Borgo Press.

Tarasiewicz M (1991) 'Women in Poland: Choices to be made', *Feminist Review,* Special Issue no. 39.

Tarasiewicz M (1993) 'Kobiety w NSZZ Solidarnosc', *Pełnym Głosem,* nr. 1 lato' 93, Fundacja Kobieca eFKa.

Tatur M (1994) ' 'Corporatism' as a paradigm of Transformation', in Staniszkis J (ed) *W Poszukiwaniu Paradygmatu Transformacji.*

Titkow A (1992) 'Women in Politics: An Introduction to the Status of Women in Poland', in Ruschemeyer M E (ed) *q.v.*

Titkow A (1994) 'Status Evolution of Polish women – the Paradox and Chances', in Alestalo M, Allardt E, Rychard A and Wesołowski W (eds) *The Transformation of Europe: Social Conditions and Consequences,* Warsaw: IFiS Publishers.

Titkow A and Domanski H (eds) (1995) *Co Znaczy Byc Kobieta w Polsce,* Warsaw: IFiS.

Titkow A (1996) *Gazetta Wyborcza,* 9 April.

Tong R (1995) *Feminist Thought: A Comprehensive Introduction,* London: Routledge.

Touraine A, Dubet F, Wiewiorka M, and Strzelecki (et al.) (1983) *Solidarity Poland 1980-81,* Cambridge: Cambridge University Press.

Verdery K (1991) 'Theorizing Socialism: A Prologue to The "Transition" ', *American Ethnologist, 18:3.*

Walczewska S (1993) 'Liga Kobiet – Jedyna Organizacja Kobieca w PRL', *Pełnym Głosem,* nr. 1 lato '93, Fundacja Kobieca eFKa.

Watson P (1992) 'Gender Relations, Education and Social Change in Poland', *Gender and Education,* Vol. 4, no. 1/2.

Watson P (1993) 'Eastern Europe's Silent Revolution: Gender', *Sociology,* Vol 27, no. 3 pp. 471-487.

Watson P (1993) 'The Rise of Masculinism in Eastern Europe', *New Left Review,* Vol. 198, pp. 71-82.

Waylen G (1994) 'Women and Democratization: Conceptualizing Gender Relations in Transition Politics', *World Politics,* Vol. 46, no. 3 April.

Wedel J (1991) *The Unplanned Society: Poland During and After Communism,* New York N.Y: Columbia University Press.

Wesołowski W (1995) 'The Nature of Social Ties and the Future of Post Communist Society: Poland after Solidarity', in Hall J (ed) *Civil Society, Theory, History Comparison,* Cambridge: Polity Press.

Wiszńiewski A (1989/90) 'Trade Union or Façade', *East European Reporter,* Vol 4, no.1.

Wolchik L and Meyer A (eds) (1985) *Women, State and party in Eastern Europe,* Duke University Press.

Żarnowskiej A and Szwarca A (redakcja) (1995) *Kobieta I Edukacja na ziemiach Polskich w xix ixx wieku,* Warsaw: Instytut Historyczny Uniwersytetu Warszawskiego.

Żarnowskiej A and Szwarca A (eds) (1995) *Kobieta I Społeczenstwo na ziemiach Polskich w xix wieku,* Warsaw: Institytut Historyczny Universytetu Warszawskiego

INDEX

Note on the author:

Belinda Brown studied Social Anthropology at the *London School of Economics*, then lived in Poland from 1991 to 1996 with her Polish partner and (from 1993) their son. During this period she taught English and studied at the *Graduate School for Social Research* at the *Institute of Philosophy and Sociology*, in the *Polish Academy of Sciences*, and then later (1995-96) studied for her MA at the *Central European University*, all in Warsaw.

She is now living with her family in London, where she has been working as a research fellow firstly at *University College* (on the ESRC 'Working Capital' project) and since then at the *Institute of Community Studies*. She is currently researching Polish immigration into Britain, and its social implications both in the UK and Poland.